THE BOOK OF
FRUITS

The Complete "Pomona Britannica"
by George Brookshaw

DAS BUCH DER FRÜCHTE

Die vollständige „Pomona Britannica"
von George Brookshaw

LE LIVRE DES FRUITS

La « Pomona Britannica » complète
de George Brookshaw

TASCHEN

KÖLN LONDON LOS ANGELES MADRID PARIS TOKYO

POMONA BRITANNICA

A masterpiece of pomology | Ein Meisterwerk der Pomologie |
Un chef d'œuvre de la pomologie

Pomology – The science of fruits

Today virtually everyone knows the names of the common and popular apple varieties, such as Golden Delicious and Granny Smith. But this has not always been the case. By the end of the 18th century thousands of different varieties of fruits were being cultivated, yet horticulturists and hobby gardeners had very little information about them. Knowing their names and other scant details was not enough to distinguish with certainty between the individual varieties. One consequence of this was that among the countless varieties of English apples a single variety could be known by several names – and these names differed not just from county to county, but even between neighbouring towns. Older fruit varieties were continually being reintroduced under different names and proclaimed as new strains of improved quality. Even inferior varieties resembling cultivated stocks were successfully passed off as the better-quality fruits. To

Pomologie – Die Wissenschaft vom Obst

Heute kennt fast jeder die Namen gängiger und beliebter Apfelsorten wie Golden Delicious und Granny Smith. Aber das war nicht immer so: Obwohl bis zum Ende des 18. Jahrhunderts Tausende von verschiedenen Obstsorten kultiviert wurden, wussten Gärtner und Gartenliebhaber über sie jedoch nur wenig. Die bloßen Namen und geringfügige zusätzliche Informationen waren unzureichend, um mit Sicherheit die einzelnen Sorten unterscheiden zu können. Dies führte zum Beispiel in England bei den unzähligen Apfelsorten dazu, dass eine Sorte unter mehreren Namen bekannt sein konnte – und zwar nicht erst in benachbarten Grafschaften, sondern bereits in Nachbarorten. Ältere Obstsorten wurden unter verschiedenen Namen wiederholt eingeführt und als neue Sorten mit verbesserter Qualität proklamiert. Es war sogar möglich, minderwertige Sorten, die den qualitativen Züchtungsergebnissen ähnlich sahen, als sehr geschätzte Früchte auszugeben.

Um dieser Verwirrung Herr zu werden, entwickelte sich im Verlauf des 18. Jahrhunderts eine bota-

La pomologie ou la science des fruits

De nos jours, qui ne pourrait citer quelques noms de variétés courantes de pommes, agréables au palais, telles que la Golden Delicious ou la Granny Smith? Mais il n'en a pas toujours été ainsi. Même si des milliers de variétés de fruits étaient cultivés à la fin du XVIIIe siècle, les jardiniers professionnels et amateurs ne savaient que peu de choses à leur sujet. Le seul nom, complété par quelques indications sommaires, ne suffisait pas à les distinguer avec précision les unes des autres. En Angleterre, par exemple, où il existait d'innombrables variétés, il n'était pas rare que l'une d'entre elles changeât de nom d'un comté à l'autre, voire d'un village à l'autre. Des variétés plus anciennes, réintroduites sous des noms différents, étaient présentées comme une sorte nouvelle, dont on vantait la qualité améliorée. Il était même possible de faire passer des fruits médiocres pour des produits très appréciés, lorsqu'ils ressemblaient à des variétés de qualité, obtenues par culture.

Afin de mettre de l'ordre dans cette confusion, une discipline spécifique se développa au cours du

THE BOOK OF
FRUITS

The Complete "Pomona Britannica"
by George Brookshaw

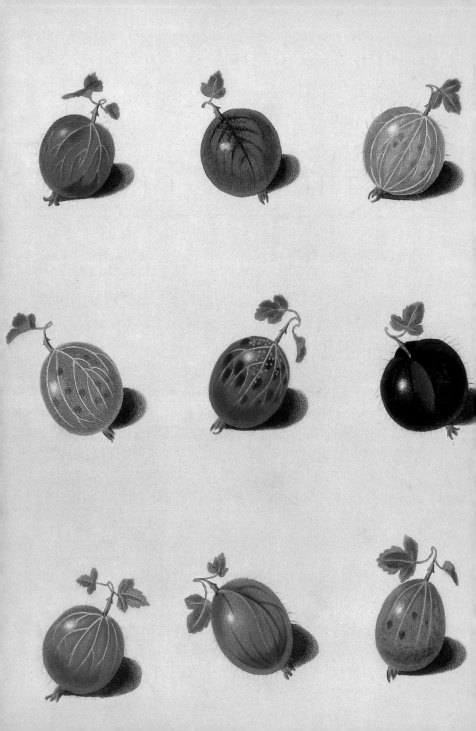

make some sense of this confusion a special branch of botany was developed in the 18th century. It is referred to as experimental pomology. This study of fruit growing and the different varieties was the first stage of the science of pomology, which only established itself in the second half of the 19th century. Not only horticulturists and nurserymen but also hobby gardeners and fruit lovers focused on describing, identifying and systematically classifying the various kinds of fruits. Books about fruit farming presented both established and new varieties in words and pictures. More specialized works on fruit varieties also emerged, which are referred to as pomonas. With the dawning of the 19th century came a blossoming of elaborately illustrated pomological print editions. The *Pomona Britannica* by George Brookshaw (published in 1812) is the most comprehensive English publication and its hand-coloured prints are regarded as among the best ever made.

nische Spezialdisziplin: die so genannte experimentelle Pomologie. Diese Lehre vom Obstbau und den Obstsorten bildete die Vorstufe der wissenschaftlichen Pomologie, die sich erst ab der zweiten Hälfte des 19. Jahrhunderts etablierte. Vor allem Gärtner und Baumschulgärtner, aber auch Garten- und Obstliebhaber konzentrierten sich auf die Beschreibung, Bestimmung und systematische Einteilung der verschiedenen Obstsorten. In Büchern über den Obstbau wurden bewährte und neue Sorten in Bild und Wort vorgestellt. Andererseits entstanden spezielle Werke über Obstsorten, die als „Pomonas" bezeichnet werden. Seit dem Beginn des 19. Jahrhunderts gipfelte die Blütezeit der pomologischen Tafelwerke in prächtigen Druckausgaben: Die *Pomona Britannica* von George Brookshaw (erschienen 1812) ist die umfangreichste englische Publikation und die kolorierten Farbdrucke zählen zu den Hochwertigsten, die je geschaffen wurden.

XVIIIe siècle : la pomologie dite expérimentale. Cette connaissance de la culture du fruit et de ses variétés prépara la naissance de la pomologie scientifique qui se constitua seulement à partir de la seconde moitié du XIXe siècle. Des jardiniers et des pépiniéristes, mais aussi des amateurs de jardins et de fruits, s'attachèrent à décrire, nommer et classer systématiquement les différentes sortes existantes. Des livres sur la culture des fruits présentèrent les variétés traditionnelles et nouvelles à l'aide de textes et d'illustrations. Des ouvrages spécialisés sur certains types de fruits parurent également, sous le nom de *Pomonas*. Illustrés de magnifiques planches pomologiques, ils connurent un formidable essor et des éditions somptueuses fleurirent à partir du début du XIXe siècle. La *Pomona Britannica* de George Brookshaw, parue en 1812, est la publication anglaise la plus complète sur la question et ses impressions en couleur en font l'une des plus précieuses jamais éditées.

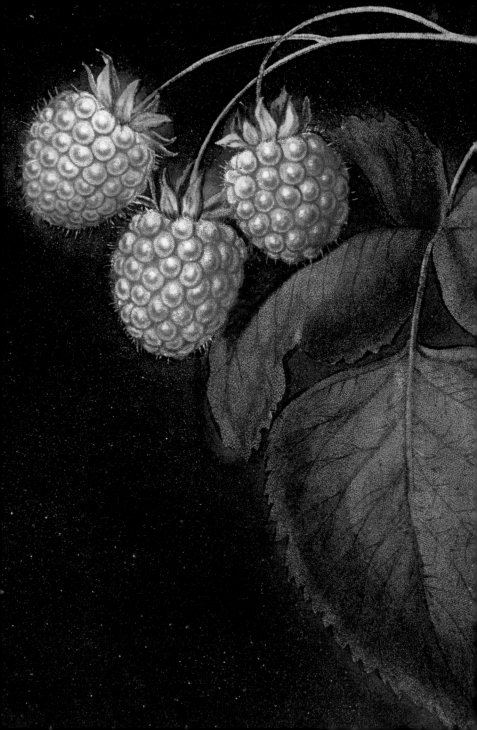

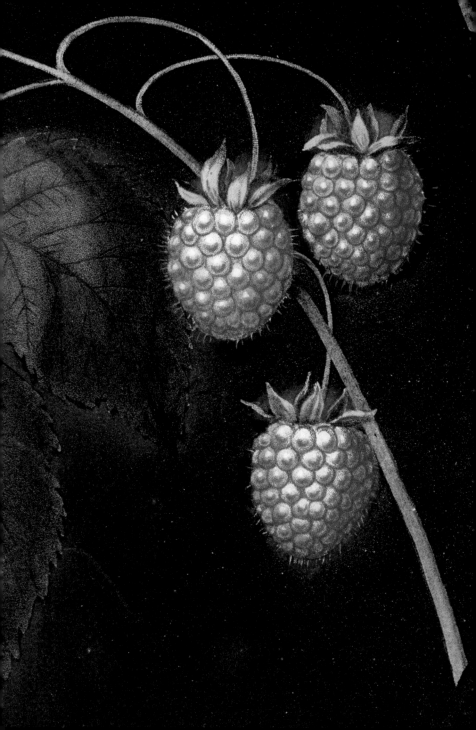

George Brookshaw's life and work

The Englishman George Brookshaw was born in Birmingham in 1751 and died in Greenwich near London in February 1823. Very little is known about his childhood, youth and training; nor is much known about his later life. Not even a portrait of him has survived. It is entirely possible that Brookshaw received instruction in art from his brother Richard Brookshaw (1736–c.1804), who was an engraver by profession. Richard was particularly well versed in the printing techniques of mezzotint and copperplate engraving – his engraved portraits after paintings by other artists made his name known beyond the British Isles. At the close of the 18th century he was even able to establish himself in Paris as a copperplate engraver.

George Brookshaw's work is only ascertainable from 1777, when as a 26-year-old he went to London to work for some 20 years as a cabinetmaker, concentrating his efforts on building very fine, intricately designed pieces of furniture. He was so successful in this trade that he managed to secure the patronage of the English royal family. Documentation of painted pieces of furniture made by Brookshaw is provided by an

George Brookshaws Leben und Werk

Der Engländer George Brookshaw wurde 1751 in Birmingham geboren und starb im Februar 1823 in Greenwich bei London. Über seine Kindheit, Jugend und Ausbildungszeit wie auch sein späteres Leben ist nur wenig bekannt; ein Porträt von ihm ist nicht überliefert. Es ist durchaus möglich, dass Brookshaw eine künstlerische Ausbildung durch seinen als Kupferstecher tätigen Bruder Richard Brookshaw (1736–um 1804) erhielt. Letzterer war vor allem in den Drucktechniken Mezzotinto und Kupferstich versiert – nicht nur auf den Britischen Inseln machte er sich mit gestochenen Porträts nach Gemälden anderer Künstler einen Namen, sondern er etablierte sich am Ende des 18. Jahrhunderts auch in Paris als Kupferstecher.

Mit Sicherheit lässt sich George Brookshaws Wirken erst mit dem Jahr 1777 erkennen: Als 26-Jähriger ging er nach London, um für die folgenden beinahe 20 Jahre als Möbeltischler tätig zu sein. Er konzentrierte sich auf die Anfertigung von sehr feinem und raffiniert gestaltetem Mobiliar. Durch seine erfolgreiche Etablierung in diesem Handwerk genoss er bald einen solch bedeutenden Ruf, dass ihm auch die Gönnerschaft des englischen Königshauses sicher war. So werden auf einer Empfangsbestätigung des

Vie et œuvre de George Brookshaw

George Brookshaw est né en 1751 à Birmingham (Angleterre) et mort en février 1823 à Greenwich près de Londres. Son enfance, sa jeunesse, ses années de formation et sa vie d'adulte nous sont peu connues, et aucun portrait de lui ne nous est parvenu. Brookshaw a probablement reçu une formation artistique de son frère Richard (1736–vers 1804), graveur sur cuivre et spécialiste des techniques d'impression du mezzotinto. Gravant des portraits peints par d'autres artistes, ce dernier s'était fait un nom sur les iles Britanniques mais aussi à Paris où il s'établit également à la fin du XVIIIe siècle, en tant que graveur sur cuivre.

L'activité de George Brookshaw est seulement attestée avec certitude à partir de l'année 1777 : à 26 ans, il se rend à Londres où il travaille pendant près de 20 ans comme ébéniste, fabriquant des meubles d'une grande finesse, dans un style très raffiné. La renommée que lui vaut ce travail de qualité lui assure aussi la protection de la maison royale d'Angleterre. Ainsi, dans le document de confirmation d'une réception donnée par le prince George (1762–1830, le roi George IV à partir de 1820) figurent des meubles peints, réalisés par Brookshaw. Des scènes allégoriques et d'admirables représentations de fruits et de bouquets de fleurs ornent les armoires, les tables et

acknowledgement of receipt by Prince George (1762–1830, from 1820 King George IV). Besides allegorical scenes, these high-quality cabinets, tables and mantelpieces displayed fine illustrations of fruits and floral bouquets. These fruit paintings on wood were an exquisite foretaste of Brookshaw's career change in the last decade of the 18th century.

Brookshaw began to focus more on his exceptional talent as a draughtsman and painter of vegetal motifs on paper. At the same time, he began to explore printing techniques he could use to best effect in reproducing his plant drawings. At the latest by the beginning of the 19th century George Brookshaw had become a valued and admired draughtsman and engraver of fruits and flowers. It was then that he embarked upon the complex and intensive work on his *Pomona Britannica*, which appeared in 1812.

The *Pomona Britannica* of 1812 – a heavenly work

Dedicated to *His Royal Highness, George,* Prince Regent and future King George IV, the *Pomona Britannica* of 1812 looks majestic even before its covers are opened. The

Prinzen George (1762–1830, seit 1820 König George IV.) bemalte Möbel dokumentiert, die Brookshaw angefertigt hatte. Die hochwertigen Schränke, Tische und Kaminsimse waren mit allegorischen Szenen sowie hervorragenden Fruchtdarstellungen und Blumenbouquets bemalt. Diese gemalten Früchte auf Holz waren quasi ein exquisiter Vorgeschmack auf Brookshaws sich verändernde berufliche Aktivitäten in den 90er Jahren des 18. Jahrhunderts. Brookshaw konzentrierte sich nun zunehmend auf sein hervorragendes Talent als Zeichner und Maler von vegetabilen Motiven auf Papier. Zugleich beschäftigte er sich intensiv mit Drucktechniken, die er zur Vervielfältigung seiner gezeichneten Pflanzen effektiv nutzen konnte. Spätestens seit dem Beginn des 19. Jahrhunderts hatte sich George Brookshaw zu einem geschätzten und bewunderten Zeichner und Stecher von Früchten und Blumen profiliert.

Die *Pomona Britannica* von 1812 –
ein paradiesisches Früchtewerk

Die *Seiner Königlichen Hoheit George,* dem Prinzregenten und späteren König George IV., gewidmete *Pomona Britannica* von 1812 ist schon im geschlossenen Zustand ein majestätisches Werk. Im Greizer Exemplar messen die Blätter 580 x 460 mm und

les dessus de cheminée qu'il peignait avec art. Ses fruits peints sur bois offrent un délicieux avant-goût de la nouvelle activité professionnelle à laquelle il se consacre à partir des années 90 du XVIII^e siècle. En effet, Brookshaw s'adonne de plus en plus à son talent de dessinateur et de peintre de motifs végétaux sur papier. Il s'intéresse aussi activement aux techniques d'impression qui peuvent lui être utiles pour la reproduction de ses dessins de plantes. A partir de la fin du XIX^e siècle, l'ébéniste est devenu un dessinateur et graveur de fruits et de fleurs apprécié et admiré.

La *Pomona Britannica* de 1812,
un ouvrage paradisiaque sur les fruits

La *Pomona Britannica* de 1812, dédiée à Son Altesse Royale le prince régent George, devenu plus tard le roi George IV d'Angleterre, est déjà en soi une œuvre royale. Dans l'exemplaire de Greiz, les pages ont un format de 580 x 460 mm et sont reliées à une couverture en cuir brun de l'époque, qui maintient solidement l'ensemble. Des bordures dorées, imprimées sur le cuir, ornent cette couverture. Un E doré, gravé au milieu des première et quatrième de couverture, représente l'initiale de la sœur de George, Elisabeth, fière propriétaire de cet exemplaire imprimé. Sur le

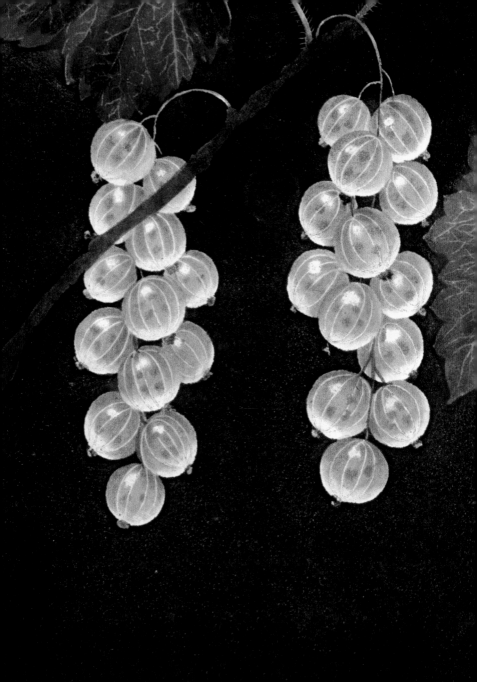

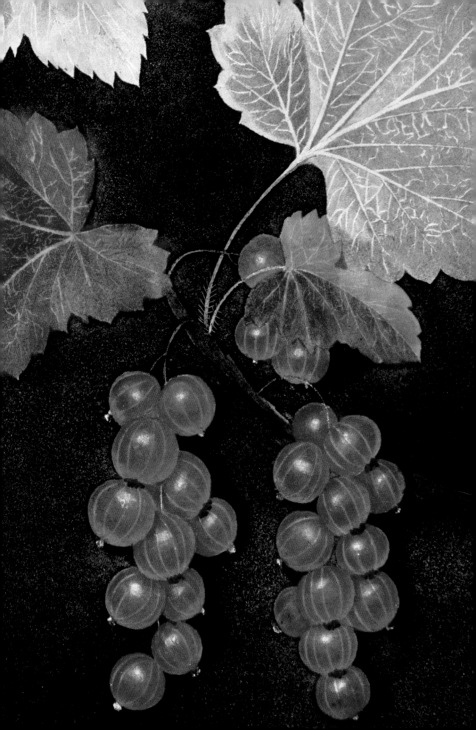

pages of the copy in the museum at Greiz measure 580 x 460 mm and are bound between two sturdy book boards covered in contemporary brown leather. Decorative gilt borders are stamped into the leather. The letter *E* is impressed in gold leaf at the centre of both the front and back covers – the initial of Prince George's sister Elizabeth, erstwhile proud owner of this printed edition. The crimson paint on the spine draws the eye to the title of the work, stamped in gilt lettering in Roman capitals: BROOKSHAW'S POMONA BRITANNICA.

George Brookshaw – initiator, author and artist – intended to present the highest-quality fruits being cultivated in the splendid royal gardens at Hampton Court and in the important gardens on the outskirts of London. With this instructive pomological work Brookshaw intended, furthermore, to address country gentlemen in particular and introduce them to the abundance of varieties in an effort to encourage more extensive cultivation.

The *Pomona Britannica* was designed to offer, particularly to noble estate owners and their gardeners, professional aid in distinguishing between the individual types of

sind zwischen zwei stabilen, mit zeitgenössischem braunem Leder überzogenen Buchdeckeln gebunden. In das Leder wurden teilweise mit einer Goldauflage versehene Schmuckbordüren eingeprägt. In der Mitte des Buchdeckels befindet sich vorder- wie rückseitig ein ebenfalls in Gold geprägtes *E* – das Signum für die Schwester George IV., Elizabeth, einst stolze Besitzerin dieses Druckexemplars. Mit dem karminroten Farbanstrich eines Buchrückenfeldes wird die Aufmerksamkeit auf den in vergoldeten Antiqua-Großbuchstaben gesetzten Titel des Werkes, BROOKSHAW'S POMONA BRITANNICA, gelenkt.

George Brookshaw – Initiator, Autor und Künstler – beabsichtigte einerseits, die besten und qualitätvollsten Früchte vorzustellen, die in den herrlichen königlichen Gärten von Hampton Court und in den am meisten geschätzten Gärten rund um London angebaut wurden. Andererseits wollte Brookshaw mit seinem pomologisch-lehrenden Beitrag vor allem die reicheren Landbesitzer, die „country gentlemen", ansprechen und durch die Vorstellung der Sortenvielfalt die extensivere Kultivierung von Früchten fördern. Die *Pomona Britannica* sollte vor allem adligen Gartenbesitzern und deren Gärtnern eine professionelle Hilfestellung zur Unterscheidung der einzelnen Fruchtsorten bieten: durch „vollständige Darlegung

dos, une surface rouge carmin met en évidence le titre du livre inscrit en lettres majuscules dorées dans le caractère Antiqua: BROOKSHAW'S POMONA BRITANNICA.

A l'initiative de ce livre, George Brookshaw en était aussi l'auteur et l'illustrateur. Son but avait été, d'une part, de présenter les plus belles et les meilleures qualités de fruits cultivés dans les splendides jardins royaux de Hampton Court ainsi que dans les jardins les plus admirés des environs de Londres. D'autre part, avec cet ouvrage didactique de pomologie, Brookshaw voulait surtout s'adresser aux propriétaires terriens les plus riches – les «country-gentlemen» – et les inciter, par une présentation des multiples variétés existantes, à pratiquer une culture plus extensive. La *Pomona Britannica* visait avant tout à apporter une aide professionnelle aux nobles, propriétaires de jardins, et à leurs jardiniers, afin de leur permettre de distinguer les différentes sortes de fruits grâce à une «présentation complète (des meilleures variétés de chaque fruit), et à une description précise de leurs caractéristiques» distinctives. Car «lorsqu'on plante un nouveau jardin, le premier souci est de choisir les variétés de fruits adéquates, qui orneront la table et permettront de réaliser les desserts les plus savoureux, en profitant si possible de toutes les pério-

fruits through "perfect delineation" of the best varieties of the various fruits "with particular descriptions of their characters" by which they distinguish themselves. For, "in planting a new garden, the first grand object is, to consider what are the proper varieties with which the table may be supplied, and the dessert set out with the highest flavored fruit, and from the earliest to the latest period possible". Whoever studied this work would soon have "a garden well planted", of which there were, according to Brookshaw, not many. The author found fault even with some of the most famous gardens in the environs of London. Another purpose of the *Pomona Britannica* was to sort out the "confusion" among the native fruit varieties, to discover their diversity and establish hitherto unknown but excellent varieties.

The way that the *Pomona Britannica* presented the fruits is convincing in every respect. To maintain some overview of the 256 fruit varieties, a practical ordering system had to be found. Fifteen selected species of fruits were presented one after another, each with their own varieties. Under the species heading the respective varieties were first described and then shown in illustrations. Starting with strawberries, the berries or

(der besten Sorten der verschiedenen Früchte) mit besonderer Beschreibung ihrer Charakteristika", anhand derer sie sich unterscheiden. Denn: „beim Bepflanzen eines neuen Gartens ist das Hauptaugenmerk zunächst darauf gerichtet, sich die passenden Obstsorten auszuwählen, mit denen der Tisch gedeckt werden kann, das Dessert mit den geschmackvollsten Früchten gestaltet werden kann und das möglichst von der frühesten bis zur letzten Erntephase". Wer dieses Werk studiere, würde bald einen „gut bepflanzten Garten" besitzen, von denen es nach Brookshaw nicht viele gab; selbst in einigen der berühmtesten Gärten um London herum stellte der Autor Mängel fest. Ein weiterer Nutzen der *Pomona Britannica* sollte die Auflösung des „Durcheinanders" unter den einheimischen Fruchtsorten sein, das Entdecken der Sortenvielfalt und die Etablierung noch unbekannter, aber exzellenter Sorten.

Die Präsentation der Früchte gelingt in der *Pomona Britannica* in jeder Hinsicht überzeugend. Um bei der großen Anzahl von 256 Fruchtsorten den Überblick zu garantieren, musste ein praktisches Ordnungsschema gefunden werden. Nacheinander werden 15 ausgewählte Fruchtarten mit ihren jeweiligen Sorten vorgestellt, wobei unter der Überschrift einer Fruchtart zunächst die zugehörigen Sorten beschrie-

des de récolte, de la plus précoce à la plus tardive». Celui qui étudierait cet ouvrage posséderait bientôt un «jardin bien planté», ce qui, d'après Brookshaw, était une rareté. Car même dans quelques-uns des jardins les plus célèbres de Londres, l'auteur constatait des lacunes. La *Pomona Britannica* devait également permettre de mettre fin à la «confusion» qui régnait parmi les variétés de fruits locales, de découvrir la multiplicité des variétés existantes et de repérer des sortes encore inconnues et pourtant excellentes.

Dans la *Pomona Britannica*, la présentation des fruits est très réussie, à tous points de vue. Pour garder une bonne vue d'ensemble, malgré les 256 variétés de fruits décrits, il a fallu trouver un ordre de classement pratique. 15 espèces de fruits, soigneusement choisies, sont présentées les unes après les autres. Pour chacune, l'auteur donne une description de ses diverses variétés, accompagnées d'illustrations. Le livre commence par les baies : fraises, framboises, groseilles et groseilles à maquereau. Leur succède toute une gamme de fruits à noyau : cerises, prunes, abricots, pêches et nectarines. Puis viennent l'ananas, les raisins et les melons, qui occupent une position dominante. Après avoir traité les noix et les figues, l'ouvrage se termine avec les fruits à pépins : poires et pommes. Dans cet ordre, la *Pomona Britannica* se lit

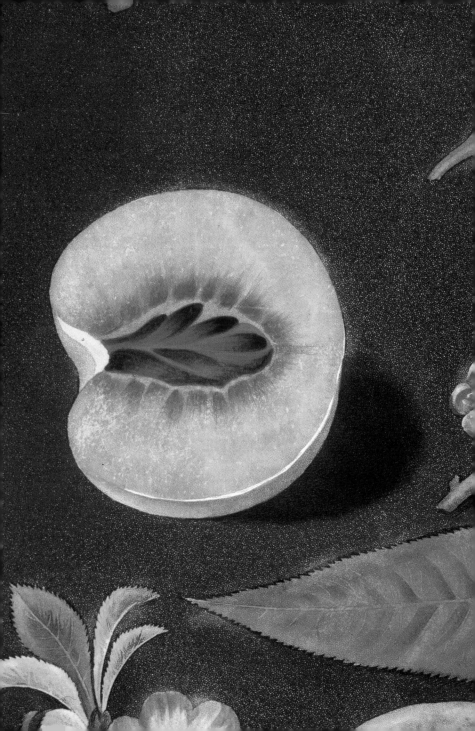

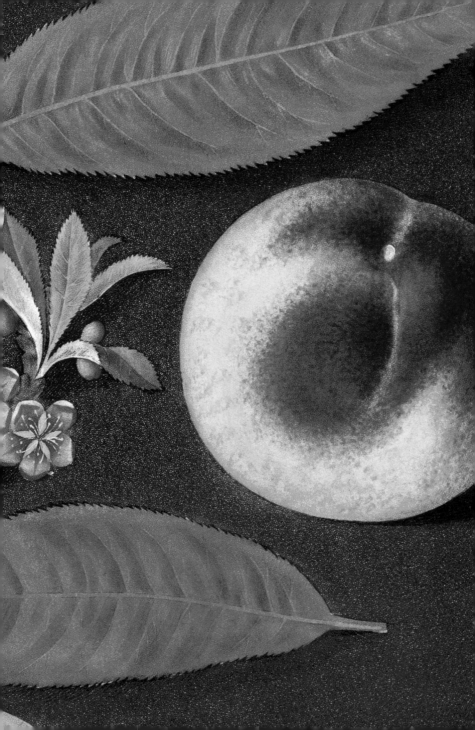

aggregate fruits were introduced: raspberries, currants and gooseberries. There followed a palette of stone fruits: cherries, plums, apricots, peaches and nectarines. Then pineapples, grapes and melons took the stage. After treating nuts and figs, the work closed with a presentation of pears and apples, the pomaceous fruit.

In this sequence, the *Pomona Britannica* also reads like a harvester's guide: opening with the early ripeners in June, strawberries, the work closes with the latecomers, apples, some varieties of which were picked at the very end of the harvesting season. Brookshaw designed the 90 plates in the *Pomona Britannica* with care. He could have consigned a plate to each variety, as numerous other contemporary work about fruits had done. But then, in order to accommodate the same number of varieties, printing costs would have risen so drastically that not even the most liberal of patrons would have obliged. To remain within the given financial constraints, Brookshaw might also have reduced the number of illustrated fruit varieties. But since his main purpose was to publish the largest-possible selection of varieties, displaying several fruits on each plate ultimately offered him the most effective use of the available pictorial space.

ben und anschließend auf Abbildungen präsentiert werden. Beginnend mit den Erdbeeren werden zunächst die Beeren- bzw. Sammelfrüchte vorgestellt: Himbeeren, Johannisbeeren und Stachelbeeren. Es folgt die breite Palette des so genannten Steinobstes: Kirschen, Pflaumen, Aprikosen, Pfirsiche und Nektarinen, dann dominieren Ananas, Weintrauben und Melonen. Nachdem Nüsse und Feigen abgehandelt sind, wird das Werk mit der Vorstellung der Birnen und Äpfel, dem Kernobst, abgeschlossen. In dieser Fruchtreihenfolge liest sich die *Pomona Britannica* auch wie ein Erntebuch: Beginnend mit den zuerst reifenden Erdbeeren ab Juni bis zu den Äpfeln, die das baldige Ende der Erntesaison einläuten und von denen einige Sorten die zuletzt zu pflückenden Früchte sind.

Die Gestaltung der 90 Tafeln in der *Pomona Britannica* hat Brookshaw wohl überlegt. Einerseits hätte er jeder Sorte eine eigene Tafel zugestehen können, wie es zahlreiche Beispiele in zeitgenössischen Früchtewerken belegen. Bei gleich bleibender Sortenzahl wären allerdings die Kosten für den Druck so enorm angestiegen, dass selbst der freizügigste Mäzen die Flucht ergriffen hätte. Um den finanziellen Rahmen nicht zu überschreiten, hätte Brookshaw andererseits die Anzahl der abzubildenden Frucht-

aussi comme un livre des récoltes. Commençant par la fraise, qui se cueille en premier, à partir du mois de juin, il se termine par les pommes qui annoncent la fin des récoltes et dont certaines variétés se ramassent très tard.

La conception des 90 planches de la *Pomona Britannica* a été mûrement réfléchie. Brookshaw aurait pu, comme de nombreux auteurs d'ouvrages de fruits à l'époque, consacrer une planche à chaque sorte. Mais les coûts d'impression auraient été si considérables que même le mécène le plus généreux aurait pris la fuite. Pour rester dans des limites financières raisonnables, Brookshaw aurait pu considérablement réduire le nombre de fruits à représenter. Mais comme il lui importait par-dessus tout de publier le plus grand nombre possible de variétés, il résolut la question en reproduisant plusieurs fruits par planche.

Les illustrations de la *Pomona Britannica* baignent dans une atmosphère douce et agréable, due surtout à la technique d'impression utilisée, l'aquatinte. Les fruits sont rarement représentés sur fond blanc mais sur des tons bruns contrastés. Voulant rendre les fruits clairement reconnaissables, Brookshaw s'était efforcé de les reproduire aussi fidèlement que possible, notamment en ce qui concerne leur taille.

The illustrations in the *Pomona Britannica* seem to glow in a sweet and soft light, which is mainly due to the printing technique used, aquatint. The fruits are rarely presented on a white background; often they are set against various shades of contrasting browns. Because Brookshaw wanted to depict the fruit varieties as true-to-life as possible, for the sake of easy recognition, he had to take their natural sizes into account as well. Accordingly, a single pineapple fills the whole picture field of a plate, or a single bunch of grapes or melon gourd. The melons, surrounded by their trailing vines, flowers and leaves, are wonderfully positioned on their rootstocks. The smaller fruits, however, are arranged in groups on the individual plates: at least two varieties each per illustration, such as for the raspberries, to a maximum of 17 varieties, such as for the gooseberries, mostly displayed in threes or fours. Thus he presented very attractive arrangements inviting the viewer to linger over plump strawberries and gooseberries, velvety purple plums, succulent pale-green pears, delicately structured pineapples and glowing red-and-yellow peaches. By contrast, most of the apples, which without their leafy bowers seem virtually naked, are composed within a quite rigid order.

sorten wesentlich reduzieren können. Doch weil er sein Hauptaugenmerk gerade auf die Veröffentlichung einer großen Sortenzahl legte, bot sich für ihn in der Präsentation von mehreren Früchten auf einer Tafel schließlich eine effektive Nutzung der Bildflächen.

Die Abbildungen in der *Pomona Britannica* strahlen eine liebliche und weiche Atmosphäre aus, was vor allem aus der angewandten Drucktechnik der Aquatinta resultiert. Die Früchte werden selten vor einem weiß belassenen Bildhintergrund präsentiert; oftmals sind sie von verschiedenen Brauntönen kontrastierend hinterfangen. Da Brookshaw die Fruchtsorten für deren Wiedererkennung möglichst naturgetreu abbilden wollte, musste er unter anderem ihre natürliche Größe berücksichtigen. Entsprechend ist bei den Ananasfrüchten, Weintrauben und Melonen nur eine, das gesamte Bildformat ausfüllende Sorte pro Tafel dargestellt. Die von Ranken, Blüten und Blättern umgebenen Melonen sind wunderbar auf einer Unterlage positioniert. Die kleineren Früchte wurden hingegen auf den einzelnen Tafeln in Gruppen arrangiert: Von mindestens zwei Sorten je Abbildung wie zum Beispiel bei den Himbeeren bis zu maximal 17 Sorten wie zum Beispiel bei den Stachelbeeren sind vor allem Früchtetrios und -quartetts präsent. Dabei gelangen Brookshaw sehr ansprechen-

C'est pourquoi chaque variété d'ananas, de raisin et de melon occupe une planche entière. Les melons, entourés de leurs vrilles, fleurs et feuilles ressortent admirablement sur le fond qui leur a été donné. Les fruits plus petits, en revanche, sont regroupés dans les différentes planches, au minimum par deux comme les framboises, au maximum par 17 comme les groseilles à maquereau, mais en général par trois ou quatre. Brookshaw a ainsi réalisé des arrangements très plaisants et très réussis de grandes fraises et de groseilles à maquereau, de fascinantes prunes violettes, de poires juteuses vert-jaunes, d'ananas parcourus de filigranes et de pêches à la peau jaune-rouge brillante, donnant au lecteur l'envie de s'attarder. En revanche, la plupart des pommes, qui paraîtraient presque nues sans leurs ornements de feuilles vertes, sont disposées selon un modèle de composition assez rigide.

Ces groupements de fruits, très étudiés, ont été beaucoup appréciés, car ils permettaient de mieux comparer encore les différentes variétés d'une même espèce. En raison du peu de place qui pouvait être consacré à chaque sorte de fruit, il fallait, dans la représentation, aller à l'essentiel, tout en respectant les principales caractéristiques morphologiques de chaque sorte : condition indispensable pour la détermination exacte des variétés et leur culture concrète

Brookshaw's carefully thought out grouping of the fruits must have been warmly received, for it provided a more effective way to compare the individual varieties of a species of fruit. The limited space available to each fruit variety meant that each reproduction had to be reduced to the essentials while still taking into account the defining morphological characteristics of the variety. This was crucial for precise identification and practical use of the varieties in horticulture, and is why the fruits were not always depicted by themselves but frequently together with characteristic sections of the plant, such as leaves and blossoms. Maximum precision was sought in representing the vegetal parts, the sizes, shapes, textures and colours, in order to facilitate recognition and distinction between the individual varieties. In reflecting the individual characteristics of the fruit varieties, appropriate selection and skilful use of the artistic techniques played an enormous role as well.

Some varieties among the impressive number of fruit illustrations are hardly distinguishable from one another. Even the leaves and blossoms are sometimes so bewilderingly similar that they would confuse anyone trying to compare them. In order for readers

de, zum Verweilen einladende Arrangements von großen Erdbeeren und Stachelbeeren, von faszinierend violetten Pflaumen, saftig gelbgrünen Birnen, filigran strukturierten Ananasfrüchten und von leuchtend gelb-roten Pfirsichen. Hingegen sind die meisten Äpfel nach einem etwas starr anmutenden Kompositionsschema angeordnet.

Brookshaws Gruppieren der Früchte wurde sehr begrüßt, da auf diese Weise die einzelnen Sorten einer Fruchtart noch effektiver miteinander verglichen werden konnten. Entsprechend der geringen, jeder Fruchtsorte zugestandenen Bildteilfläche musste die Wiedergabe der einzelnen Sorten unter Berücksichtigung der jeweils wichtigen morphologischen Kennzeichen jeder Sorte auf das Wesentliche reduziert werden. Dies war für eine exakte Bestimmung und für die Nutzung der Sorten im praktischen Obstbau unabdingbar. Daher sind oftmals nicht nur die Früchte, sondern auch charakteristische Ausschnitte der jeweils Frucht tragenden Pflanze wie Blätter und Blüten dargestellt. Um eine Erfolg versprechende Wiedererkennung und Unterscheidung der einzelnen Sorten zu garantieren, wurde eine möglichst exakte Wiedergabe der vegetabilen Pflanzenteile in Größe, Form, Materialität und Farbe angestrebt. Um den Fruchtsorten ihr jeweils charakteristisches Aussehen

dans les vergers. C'est pourquoi les illustrations ne se limitent pas à la représentation des seuls fruits mais s'efforcent aussi de donner un aperçu des éléments caractéristiques de la plante porteuse, comme les feuilles et les fleurs. L'auteur a donc cherché à reproduire avec autant d'exactitude que possible les différentes parties de la plante, dans le respect des dimensions, des formes, des matières et des couleurs. Le choix et la maîtrise des techniques artistiques adéquates a également joué un rôle considérable dans cette tentative de donner à chaque variété son apparence caractéristique. Parmi la quantité considérable de fruits représentés, il existe toutefois quelques sortes d'apparence très semblable. La ressemblance va parfois jusqu'aux feuilles et aux fleurs. Mais pour dispenser le maximum de connaissances pomologiques et permettre au lecteur de tirer le meilleur parti des reproductions, celles-ci sont toutes précédées d'une description écrite de la variété correspondante dont elle énumère les caractéristiques importantes – telles que le goût ou les meilleures manières de les utiliser – qui ne peuvent pas se représenter dans une image.

to derive the full benefit of the available pomological knowledge, each illustration was preceded by a description of the individual varieties depicted. The associated text outlines characteristics that cannot be illustrated, such as the flavour of the pulp and preferred uses of the fruits.

Of the originally anticipated 93 plates from the *Pomona Britannica* only 90 have been included here. The numbering of the plates in the present catalogue conforms to that of the original publication, the two exceptions being plates 19 and 20, which have been reallocated to the species to which they belong. The names of the varieties in the legends refer to the fruits on the plates in order from top left to bottom right. Missing varieties or those that could not be classified are indicated by a dash.

zu geben, spielte auch die Auswahl und der Umgang mit den künstlerischen Techniken eine enorme Rolle. Bei der beeindruckenden Anzahl abgebildeter Früchte sind einige Sorten dabei, die sich nur minimal voneinander unterscheiden. Selbst die Blätter und Blüten sind manchmal so verblüffend ähnlich, dass sie den Betrachter beim Vergleichen der Sorten verwirren. Um den Gewinn an pomologischem Wissen und die bildliche Präsenz der Fruchtsorten in vollen Zügen genießen zu können, sind die Abbildungen durch jeweils vorangestellte Beschreibungen der einzelnen Sorten ergänzt worden. In den zugehörigen Texten sind nicht darstellbare Fruchtmerkmale wie zum Beispiel der Geschmack des Fruchtfleisches und bevorzugte Verwendungsmöglichkeiten der Früchte beschrieben.

Von den ursprünglich vorgesehenen 93 Tafeln der *Pomona Britannica* wurden nur 90 ausgeführt. Der folgende Katalog übernimmt Brookshaws englische Früchtenamen und folgt in der Numerierung der abgebildeten Tafeln durchgängig dem Original, lediglich die Abfolge der Tafeln 19 und 20 wurde er Gruppierung der Arten angepasst. Die Sortennamen in den Legenden richten sich nach der Abfolge der Früchte auf den Tafeln von links oben nach rechts unten. Fehlende oder nicht bestimmbare Sorten werden mit einem Gedankenstrich angezeigt.

Sur les 93 planches prévues à l'origine de la *Pomona Britannica*, 90 seulement ont été réalisées. Ce catalogue suit la numérotation des planches illustrées conformément à l'original, sauf exception pour les planches 19 et 20 qui ont été regroupées sous les espèces auxquelles elles appartiennent. Dans les légendes, les noms des variétés se rapportent aux fruits illustrés sur les planches, de haut en bas et de gauche à droite. Les variétés manquantes ou indéterminées sont indiquées par un tiret.

STRAWBERRIES
Erdbeeren | Fraises

Although the botanical genus *Fragaria* seems to be relatively prevalent, actually only two species of strawberries played a lastingly significant role in its cultivation: the Chilean Beach Strawberry, *Fragaria chiloensis*, and the Meadow Strawberry, *Fragaria virginiana*. A cross between the two species led to our current garden hybrids. The Latin names reveal the American origins of the plants and consequently their relatively late arrival in European fruit baskets. Previously, wild relatives were commonly cultivated in Europe, whose deficiency in size was more than compensated by aromatic flavour.

All these traditional species were largely supplanted by the two American imports. They were initially grown with mixed success in European gardens until a cross between the small-fruited but aromatic, productive and hardy Meadow Strawberry and the firm-fleshed, sweet and somewhat lighter Chilean giant strawberry eventually led to the breakthrough in efforts to breed an economically viable product. The characteristic flavour of this stately fruit led some to equate it with the pineapple, hence its German name *Ananas-Erdbeere*. It became the stock of practically all later varieties.

Obwohl sich die botanische Gattung *Fragaria*, Erdbeere, relativ umfangreich präsentiert, spielten eigentlich nur zwei Arten eine nachhaltig tragende Rolle: die Chile-Erdbeere, *Fragaria chiloensis*, und die Scharlacherdbeere, *Fragaria virginiana*, denn ihre Kreuzung führte zu unseren heutigen Gartenerdbeeren. Die lateinischen Namen verraten bereits die amerikanische Herkunft der Pflanzen und erst relativ spät bereicherten die verlockenden Früchte die europäische Fruchtpalette. Dort wurden sie bis dahin durch ihre wild wachsende Schwester, die Walderdbeere, vertreten, deren volles Aroma immerhin aufwiegen kann, was den Früchten an Größe fehlt.

Alle diese überkommenen Arten wurden jedoch durch die Einfuhr der beiden amerikanischen Arten weitgehend verdrängt. Anfangs in den europäischen Gärten noch mit wechselndem Erfolg gezogen, brachte die Kreuzung der kleinfruchtigen, aber aromatischen, tragfreudigen und winterfesten Scharlacherdbeere mit der festfleischigen, süßen und etwas helleren chilenischen Riesen-Erdbeere schließlich den züchterischen und wirtschaftlichen Durchbruch. Wegen ihres charakteristischen Aromas erhielten die stattlichen Früchte den Namen „Ananas-Erdbeere". Sie wurden zur Urform praktisch aller späteren Züchtungen.

Bien que le genre *fragaria* (fraise) soit assez diversement représenté, seules deux espèces ont joué un rôle durable: la fraise du Chili, *fragaria chiloensis*, et la fraise écarlate, *fragaria virginiana*, car leurs croisements ont conduit à nos fraises de jardin d'aujourd'hui. L'origine américaine de ces deux espèces, que nous révèlent leurs noms latins, explique que ce fruit tentant ne soit venu enrichir qu'assez tardivement la palette européenne. En Europe, la fraise n'était connue jusque-là que par sa sœur sauvage, la fraise des bois, dont l'arôme puissant compense une taille très réduite.

Toutes ces espèces traditionnelles furent largement supplantées par l'arrivée des deux américaines. En effet, le croisement entre la fraise écarlate, aromatique, de petite taille, mais très productive et résistante au froid hivernal, et la fraise géante du Chili, à chair ferme, sucrée et un peu plus claire, donna des fruits dont la culture connut tout d'abord un succès variable dans les jardins mais qui réussirent finalement à s'imposer sur les marchés et chez les cultivateurs. En raison de leur arôme caractéristique, ces variétés de belle apparence furent appelées «fraises ananas», et devinrent la source de pratiquement toutes les autres développées par la suite.

PLATE I
Early Scarlet Strawberry · Late Scarlet · Golden Drop · Pine
Frühe Scharlachrote Erdbeere · Späte Scharlachrote Erdbeere · Golden Drop · Ananas-Erdbeere
Ecarlate précoce · Ecarlate tardive · Golden Drop · Fraise d'ananas

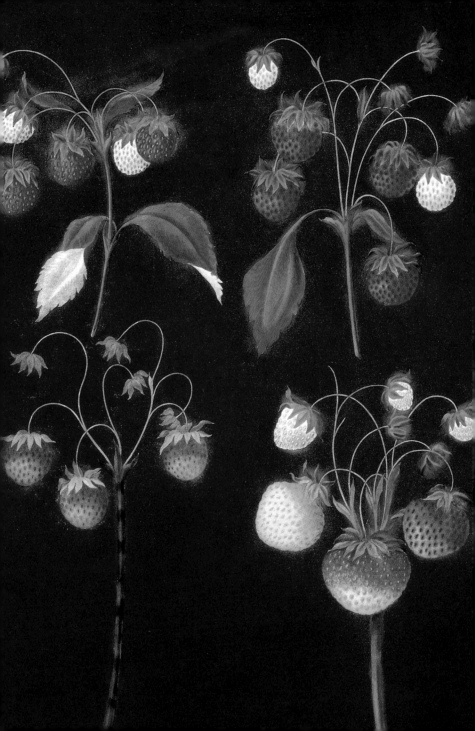

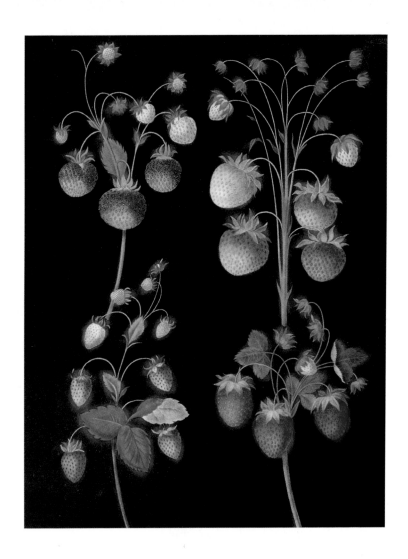

PLATE II
Hautboy Strawberry · Chili-Strawberry (Pine Strawberry) · Alpine Red Strawberry · Scarlet Flesh Strawberry
Hautboy-Erdbeere · Riesen- oder Chile-Erdbeere · Scharlachrote Alpen-Erdbeere · Erdbeere mit scharlachrotem Fleisch
Fraise Hautboy · Fraise du Chili (Fraise d'ananas) · Ecarlate alpine · Fraise à chair écarlate

PLATE III
New Early Prolific (Scarlet Strawberry) · Wood Strawberry · White Alpine
Frühe Fruchtbare Scharlachrote Erdbeere · Walderdbeere · Weiße Alpen-Erdbeere
Fertile hâtive · Fraise des bois · Alpine blanche

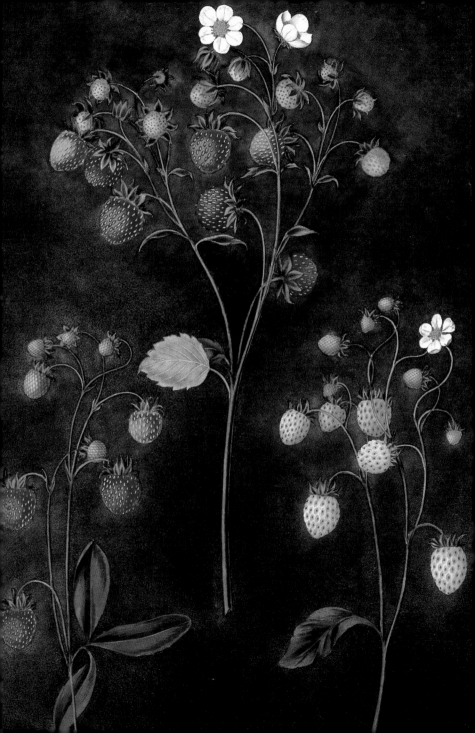

RASPBERRIES
Himbeeren | Framboises

The German name, *Himbeere* (formerly *hintber*), for this native of Asia derives from the word hind or doe. We do not know what inspired this name but perhaps these animals and their young savoured the exquisite berries as much as our human forebears. In the strictly botanical sense these are not individual berries, as their name would lead us to think, but an aggregate fruit formed of multiple little hairy drupes that are connected together and easily come off their conical base as a single unit. So the actual edible part of the raspberry when picked is a hollow cup shape. When fresh the fruit dissolves on the tongue with an overwhelming aromatic tang that does not lose its vitality when prepared as jam, dessert or ice-cream, or even as vinegar, syrup, wine or liqueur. This distinctive taste naturally prompted cultivators to try out variations. The resulting hybrids from crosses with species of blackberries, such as the Loganberry (1881) and Black Boysenberry (around 1920), have since managed to gain a considerable share of the market.

Nach der Hirschkuh, der Hinde, wurde die in Asien beheimatete Himbeere benannt, die früher „hintber" hieß. Was den Anlass zu diesem Namen gab, wissen wir nicht, aber vielleicht erfreuten sich die Tiere mit ihren Jungen ebenso am exquisiten Aroma der Früchte, wie auch der Mensch dies seit langem tut. Im streng botanischen Sinn handelt es sich allerdings nicht um eine einzelne Beere, wie der Name vorgaukelt, sondern um eine Sammelfrucht aus lauter kleinen, haarigen Steinfrüchtchen, die zusammenhängen und sich als Ganzes leicht vom zapfenartigen Fruchtboden lösen, so dass als eigentliche, das heißt essbare Himbeere ein hohler Becher übrig bleibt. Frisch genossen entfaltet er, auf der Zunge zergehend, ein überwältigendes Aroma, das die Früchte aber auch verschwenderisch an Zubereitungen weitergeben, von der Marmelade über Süßspeisen bis hin zum Eis, zum Himbeeressig, -sirup, -wein und -wasser. Natürlich reizte ein solches Geschmackserlebnis die Züchter zu dem Versuch, es zu variieren, und so entstanden durch Kreuzung mit Brombeerarten zum Beispiel die Loganbeere (1881) und die schwarze Boysenbeere (um 1920), die sich seither zumindest Teilmärkte erobern konnten.

Originaire d'Asie, la framboise est nommée en allemand d'après la biche, *Hinde*, qui a donné *hintber* puis « Himbeere ». En français, framboise vient de *brambasia*, qui veut dire « mûre » ou d'un mot du XIIe siècle, « frambaise », qui a pu donner « fraise ». Pourquoi dériver ce mot de la biche dans la langue allemande? Nous ne le savons pas. Peut-être ces animaux et leurs petits se régalaient-ils tout autant que nous de ces baies exquises. A strictement parler, la framboise n'est toutefois pas une simple baie mais un fruit composé d'une multitude de minuscules baies velues, à pépins, qui, ensemble, se détachent facilement du fond conique, pour constituer la partie comestible du fruit, en forme de godet. Quand elle fond sur la langue, la framboise fraîche dégage un arôme pénétrant, qui se transmet généreusement à toutes les préparations réalisées à partir de ce fruit: confitures, desserts, glaces, vinaigres, sirops, alcools et eaux-de-vie. Les cultivateurs ont évidemment tenté de trouver de multiples variantes à cette riche saveur et ont ainsi créé, par croisement avec des variétés de mûres, par exemple la *Loganberry* (ronce-framboise) (1881) et la boysenberry noire (vers 1920) qui, depuis, ont su conquérir certains marchés.

PLATE IV
White Antwerp Raspberry · Red Antwerp Raspberry
Weiße Antwerpener Himbeere · Rote Antwerpener Himbeere
Framboise d'Anvers à gros fruit blanc allongé · Framboise d'Anvers à gros fruit rouge allongé

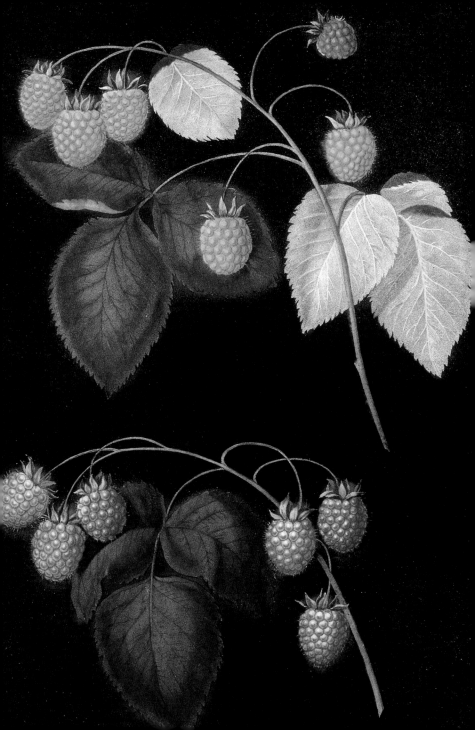

CURRANTS
Johannisbeeren | Groseilles · Cassis

John the Baptist is the patron saint of this fruit because it ripens around his feast day, on June 24th. Evidence in our gardens of the currant dates back to the 15th century. The red or yellowish-white berries, formed from their racemes, have been popular ever since for their refreshing sour taste. Blackcurrants differ from their sister varieties not only in flavour but particularly in their content of vitamin C, which is as much as five times higher. Currants are classified among the botanical family *Saxifragaceae*. Being indigenous to northern Europe and America, they were unknown to the Ancient Greeks. The term widely used in southern Germany and Austria for the berries and their related delicious recipes, *Ribisel*, derives from their Latin designation *ribes* – after the name of a sour-tasting species of rhubarb.

Johannes der Täufer fungiert bei ihr als Pate, weil ihre Früchte um den 24. Juni, den Johannitag, reif werden. Seit dem 15. Jahrhundert ist die Johannisbeere in unseren Gärten nachweisbar und seitdem sind die aus den Blütentrauben entstehenden roten oder gelblich-weißen Beeren wegen ihres erfrischend sauren Geschmacks beliebt. Daneben gibt es auch die Schwarze Johannisbeere, die sich nicht nur im Geschmack von ihren Schwestern unterscheidet, sondern insbesondere durch ihren etwa fünfmal höheren Vitamin-C-Gehalt. Botanisch gehört die Johannisbeere zu den Steinbrechgewächsen (*Saxifragaceae*). Sie ist im Norden Europas und Amerikas beheimatet und war deshalb in der Antike unbekannt. Von ihrem lateinischen Namen *ribes* – nach der Bezeichnung einer sauer schmeckenden Rhabarberart – leitet sich auch das in Süddeutschland und Österreich verbreitete „Ribisel" für die Beeren und daraus hergestellte leckere Zubereitungen ab.

Appelée en allemand la « baie de Jean » parce que ses fruits mûrissent vers le 24 juin, jour de la Saint-Jean, la groseille est attestée dans nos jardins depuis le XVᵉ siècle et les baies jaune-blanc ou rouges qui naissent de ses grappes de fleurs ont toujours été appréciées à cause de leur acidité rafraîchissante. Son frère noir, le cassis, se distingue non seulement par son goût mais aussi par une teneur cinq fois plus forte en vitamine C. Dans la classification botanique, la groseille fait partie des saxifragacées. Provenant du nord de l'Europe et d'Amérique, ce fruit était inconnu dans l'Antiquité à cause de ses origines. De son nom latin *ribes*, qui désigne une variété acide de rhubarbe, découle aussi le terme de « Ribisel », répandu au sud de l'Allemagne et en Autriche pour désigner les groseilles et les délicieuses spécialités à base de ce fruit.

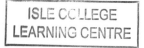
PLATE V
Black Currant · White Currant · Dutch Red Currant
Schwarze Johannisbeere · Englische weiße Johannisbeere · Holländische rote Johannisbeere
Cassis · Groseille d'Angleterre à fruit blanc · Groseille de Hollande à fruit rouge

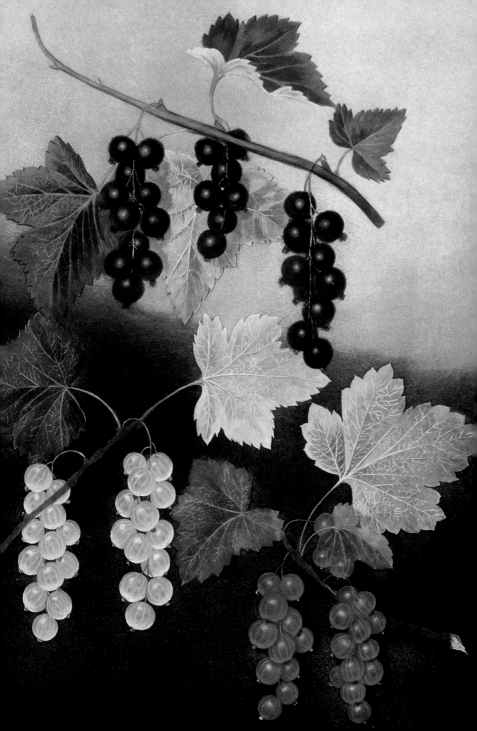

GOOSEBERRIES

Stachelbeeren | Groseilles à maquereau

The 13th-century French poet Rutebeuf was probably the first to mention gooseberries, *Ribes uva-crispa* L., and to record them as *groiselles*. The earliest known illustration dates from 200 years later, though, as a marginal sketch not in the botanical literature but in a prayer book, the *Breviarium Grimani*, which appeared around 1510–1520. Three decades elapsed before gooseberries were also featured in herbals, first in that of Leonhard Fuchs (1543), even though cultivars were evidently already being grown in many gardens. These unassuming berries all originate from wild varieties native to Europe and Asia, which were selectively cultivated from the 15th century onward to improve their size and flavour. The greatest advances were made in the 18th century, however, in England, where they were successfully crossed with North American species in 1705. By the end of that century some 100 different varieties were known – Brookshaw even speaks of more than 1000 – with white, yellow, green or red berries that were often covered in prickly hairs.

Der im 13. Jahrhundert lebende französische Dichter Rutebeuf war wohl der Erste, der die Stachelbeere, *Ribes uva-crispa* L., erwähnte und ihr den Namen „groiselle" gab. 200 Jahre später findet sich die früheste bekannte Abbildung, aber nicht in der botanischen Literatur, sondern als Randzeichnung in einem Gebetbuch, dem um 1510–1520 entstandenen *Breviarium Grimani*. Erst drei Jahrzehnte später erscheint die Stachelbeere auch in den Kräuterbüchern, erstmals bei Leonhart Fuchs (1543), obwohl damals Zuchtformen offenbar schon in vielen Gärten anzutreffen waren. Sie stammten alle von der in Europa und Asien einheimischen Wildform ab, die seit dem 15. Jahrhundert zur Verbesserung der Größe und des Geschmacks ihrer unscheinbaren Beeren kultiviert wurde. Der große Durchbruch wurde aber erst im 18. Jahrhundert in England erzielt, wo man seit 1705 nordamerikanische Stachelbeer-Sorten erfolgreich einkreuzte, so dass am Ende des Jahrhunderts bereits etwa 100 verschiedene Sorten – Brookshaw spricht sogar von über 1000 – mit weißen, gelben, grünen oder roten, teils borstig behaarten Beeren bekannt waren.

Le poète français du XIII^e siècle, Rutebeuf, a sans doute été le premier à mentionner la groseille à maquereau, ou *ribes uva-crispa* L., qu'il appelait «groiselle». 200 ans plus tard, on en trouve la première illustration connue, non pas dans un ouvrage de botanique mais dans un livre de prière, le *Breviarium Grimani*, écrit vers 1510–1520. Il faut attendre encore trente ans avant que la groseille à maquereau ne fasse son entrée dans les livres d'herboristerie, le premier étant celui de Leonhart Fuchs (1543), bien qu'à l'époque, on trouvait déjà des formes cultivées dans nombre de jardins. Elles provenaient toutes d'une même variété qui poussait à l'état sauvage en Europe et en Asie et qui fut cultivée à partir du XV^e siècle pour améliorer la taille et le goût de ces baies de peu d'apparence. Mais la grande percée de la groseille à maquereau date du XVIII^e siècle, en Angleterre, depuis qu'on la croisa, à partir de 1705, avec sa sœur américaine pour obtenir, dès la fin du siècle, une centaine de sortes nouvelles – plus de 1000 d'après Brookshaw – aux baies blanches, jaunes, vertes ou rouges, et au duvet parfois rêche.

PLATE VI

Early Green Hairy · Child's Golden Lion · Alcock's Duke of York · Lomaxe's Victory · Mill's Champion · Warrington Red · Mill's Langley Green · Eden's Elibore · Hill's Sir Peter Teazle · Woodwards White-Smith · Tillotson's Seedling · Warwickshire Conqueror · Rawlinson's Duke of Bridgewater · Clyton's Britania · Hall's Porcupine · Arrowsmith's Ruler of England · Fox's Jolly Smoker

Frühe Grüne Stachelbeere · Wunderbare Rauchbeere · Alcock's Duke of York · Lomaxe's Victory · Mill's Champion · Unvergleichliche Rauchbeere · Mills Grüne · Eden's Elibore · Hill's Sir Peter Teazle · Feinriechende Zungenbeere · Tillotsons Sämling · Eroberer von Warwickshire · Rawlinson's Duke of Bridgewater · Spätreifende Wendelbeere · Hall's Porcupine · Arrowsmith's Ruler of England · Fox's Jolly Smoker

Green Gascoigne · — · Alcock's Duke of York · Victoire · Mill's Champion · Warrington Red · Mill's Langley Green · Eden's Elibore · — · White-Smith · — · — · Rawlinson's Duke of Bridgewater · Clyton's Britania · Hall's Porcupine · Arrowsmith's Ruler of England · Fox's Jolly Smoker

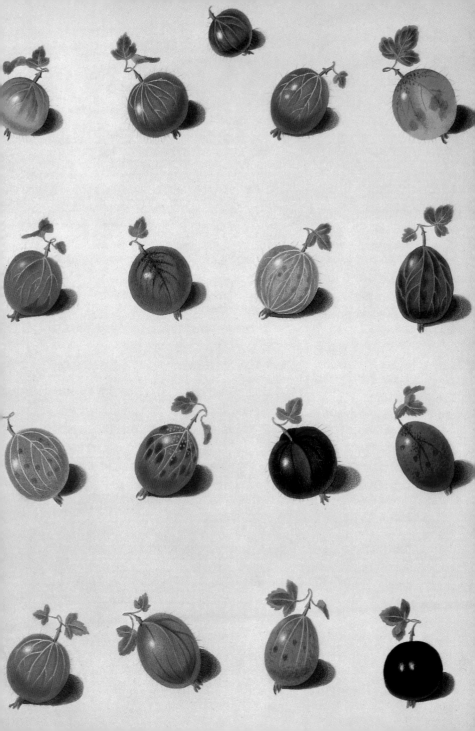

CHERRIES
Kirschen | Cerises

If we are to believe Pliny, then it was Lucullus who brought cherries to Rome in 64 B.C. from Cerasus on the Black Sea, now known as Giresun in Turkey. But it remains unclear whether a particularly tasty cultivar of the Sweet Cherry native to Europe, *Prunus avium*, was involved or the Sour Cherry, *Prunus cerasus*, which is prevalent throughout Asia Minor. The two varieties have only been clearly distinguished since the early 19th century and are botanically closely related to plums, peaches and apricots. In any event the wild varieties were a part of human life at least since the Stone Age, as is evidenced by cherry-stone finds among settlement remains.

By the mid-16th century about 15 different varieties were known; today that figure has risen to many hundreds. From the sour *Glaskirsche*, crossbred in the 17th century from sweet and sour cherries, the Hard-Fleshed Cherry was developed which still dominates the market today alongside the softer Heart Cherry. One particular variety of sour cherry, the Marasca, formerly native to the Balkans, is used to produce maraschino liqueur.

Glauben wir Plinius, dann war es Lukullus, der 64 v. Chr. aus Cerasunt am Schwarzen Meer, dem heutigen Giresun in der Türkei, die Kirschen nach Rom brachte. Es bleibt aber unklar, ob es sich dabei um eine besonders wohlschmeckende Zuchtsorte der in Europa heimischen Süßkirsche, *Prunus avium*, oder aber der in Kleinasien verbreiteten Sauerkirsche, *Prunus cerasus*, handelte. Beide Sorten wurden erst seit dem frühen 19. Jahrhundert klar unterschieden und sind botanisch eng mit Pflaume, Pfirsich und Aprikose verwandt. Jedenfalls begleiteten Wildformen den Menschen mindestens schon seit der Steinzeit, wie Funde von Kirschkernen in Siedlungsresten belegen.

In der Mitte des 16. Jahrhunderts kennt man etwa 15 verschiedene Sorten, heute sind es viele hundert. Über die im 17. Jahrhundert durch Kreuzung von Süß- und Sauerkirsche gezüchtete Glaskirsche wurden die festfleischigere Knorpelkirschen gezüchtet, die sich noch heute neben den weicheren Herzkirschen auf dem Markt behaupten. Ehemals auf dem Balkan heimisch war auch eine besondere Varietät der Sauerkirschen, die Maraska-Kirsche, aus der der Maraschino-Likör hergestellt wird.

A en croire Pline, ce fut Lucullus qui, en 64 av. J.-C., rapporta la cerise à Rome. Il l'avait découverte à Cérasonte sur la mer Noire, aujourd'hui Giresun en Turquie. Toutefois, nous ignorons s'il s'agissait d'une variété cultivée, particulièrement savoureuse, de la cerise douce, originaire d'Europe, appelée *prunus avium*, ou de la griotte acide (*prunus cerasus*), très répandue en Asie mineure. Les deux sortes n'ont été clairement distinguées qu'au début du XIXe siècle et sont étroitement apparentées à la prune, à la pêche et à l'abricot. Des formes sauvages de ces fruits rouges étaient déjà connues à l'âge de pierre, comme en témoignent des noyaux de cerise trouvés dans des vestiges d'anciens sites habités.

Au milieu du XVIe siècle, on en connaissait environ 15 sortes différentes et aujourd'hui plusieurs centaines. Par croisement entre cerises douces et acides, on obtint, au cours du XVIIe siècle, la griotte de culture, qui à son tour donna naissance au bigarreau, à chair ferme, encore bien présent aujourd'hui sur le marché, et à la guigne, plus tendre. Une variété particulière de cerise acide, la marasque, originaire des Balkans, parfume la liqueur appelée marasquin.

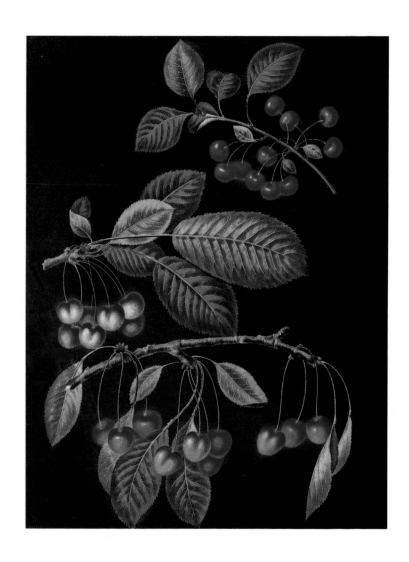

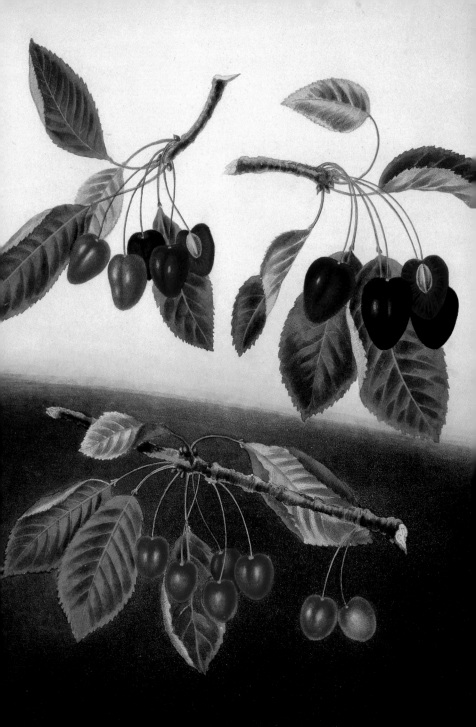

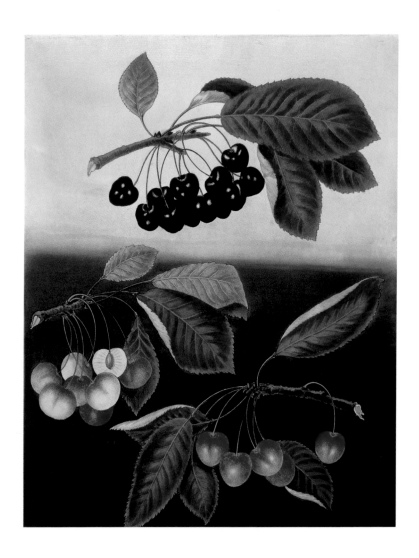

PLATE X
George the Second's Cherry · Groffien or Biggarou · Harrison's Heart
Holländische Große Prinzessinkirsche · Groffien oder Biggarou · Harrison's Heart
Gros bigarreau de Princesse de Hollande · Bigarreau · Harrison's Heart

PLATE XI
Tradescant Cherry · Millet's Duke · Amber Heart Cherry
Große Schwarze Knorpelkirsche · Frühe Herzogkirsche · Frühe Bernsteinkirsche
Bigarreau gros noir · Cerise précose de mai · Guigne jaune

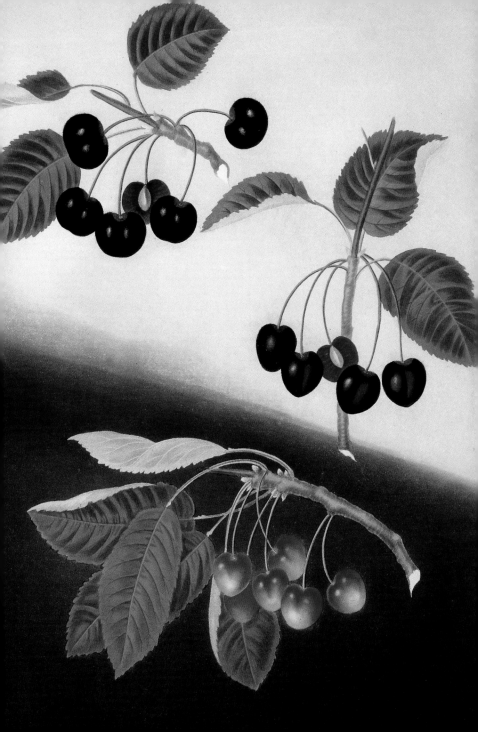

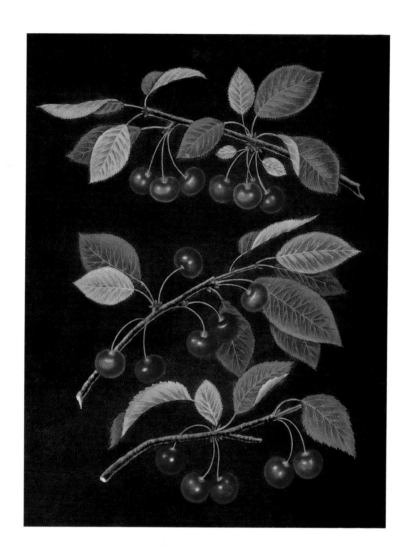

PLATE XII
Kentish or Flemish Cherry · English Bearer · Carnation Cherry
Flamentiner · Bleichrote Glaskirsche · Rote Oranienkirsche (Fleischfarbige Kirsche)
Flamentin · Cerise nouvelle d'Angleterre · Cerise rouge d'Orange

PLATE XIII
Morello · Caroon · Ronolds Black Heart
Brüsseler Braune · Englische Schwarze Kronenkirsche · Tartarische Schwarze Herzkirsche
Cerise guigne · Guigne de couronne · Cœur noir de Ronold

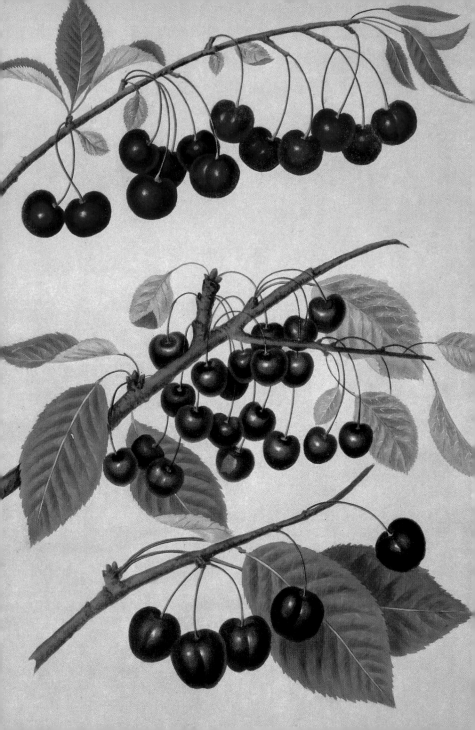

PLUMS
Pflaumen | Prunes

Whatever tastes good is probably not healthy. That hard truth happily does not apply to plums. This delicious source of vitamins provides essential roughage for a weak digestion and was administered long before the doctor prescribed it to Molière's immortal hypochondriac, Monsieur Argan.

Today it is proliferated practically worldwide from over 2000 breeding stations. The term plum is actually only a general designation for various species, some of them hardly distinguishable. The Round or Egg Plum is among them, of course. Its generally purplish blue fruits are divided by an obvious seam and are quite soft and very succulent when ripe. The stone is not easily separated from the flesh, however. The damson is named after the Syrian city of Damascus. The flesh of this elongated, oval fruit does not contain as much water as round plums and is hence firmer, a perfect fruit for tarts. Finally, the spherical little Mirabelles should also be mentioned as particularly well suited for stewing.

Was gut schmeckt, ist zumeist nicht gesund. Diese schmerzliche Erfahrung trifft erfreulicherweise auf die Pflaume keineswegs zu. Sie ist nicht nur ein leckerer Vitaminspender, ihre Ballaststoffe helfen auch der Verdauung nach und dies nicht erst seit ihrer ärztlichen Empfehlung an Monsieur Argan, dem von Molière unsterblich gemachten Eingebildeten Kranken.

Heute sind sie in über 2000 Zuchtsorten praktisch weltweit verbreitet. Dabei ist der Begriff Pflaume eigentlich nur eine Sammelbezeichnung für verschiedene, teilweise schwer zu unterscheidende Arten. Natürlich gehört dazu zuerst die Echte Pflaume, auch Rund- oder Eierpflaume genannt. Ihre zumeist blau-violetten Früchte lassen eine deutliche Naht erkennen und sind zur Reifezeit relativ weich und sehr saftig. Der Stein löst sich allerdings nur schwer vom Fruchtfleisch. Als „Damaszener Pflaume", benannt nach dem syrischen Damaskus, wurde die dunkelblaue Zwetsch(g)e in Europa bekannt. Das Fruchtfleisch der länglicheren und spitz-oval zulaufenden Früchte enthält nicht so viel Wasser wie das der Rundpflaume, ist deshalb fester und als Kuchenbelag bestens geeignet. Und schließlich wäre noch die kleine, ebenfalls gelbe und kugelige Mirabelle zu erwähnen, die sich besonders als Kochobst eignet.

Ce qui est bon au goût n'est souvent pas bon pour la santé. Fort heureusement, cette constatation douloureuse ne s'applique pas à la prune. Délicieuse, riche en vitamines, elle était déjà connue pour ses propriétés laxatives bien avant d'avoir été recommandée à Argan, le malade imaginaire immortalisé par Molière.

Avec plus de 2000 variétés, cet arbre fruitier est pratiquement implanté aujourd'hui dans le monde entier. Cependant, le mot de prune n'est qu'un terme générique pour désigner de multiples variétés, parfois très difficiles à distinguer les unes des autres. Parmi celles-ci, on compte évidemment en premier lieu la prune proprement dite, de forme ronde ou ovoïde. Ce fruit, généralement d'un bleu violet, présente une très nette couture à sa surface, et à maturité, est relativement tendre et extrêmement juteux. Le noyau se détache difficilement de la chair. Connue d'abord sous le nom de « prune de Damas », la quetsche bleu foncé s'est à son tour répandue en Europe. La chair de ce fruit plus allongé, ovale ou pointu aux extrémités, ne contient pas autant d'eau que celle de la prune ronde. La plus grande fermeté de sa chair la prédestine aux fonds de tarte. Pour finir, il convient encore de mentionner la petite mirabelle, également jaune et toute ronde, qui se prête particulièrement à la cuisson.

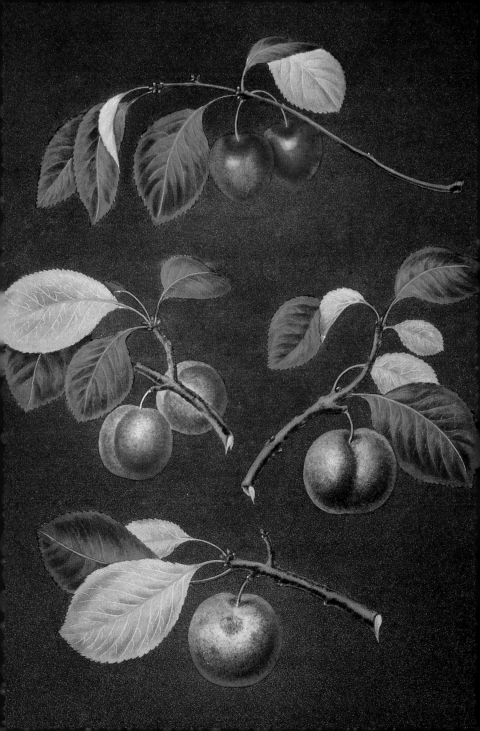

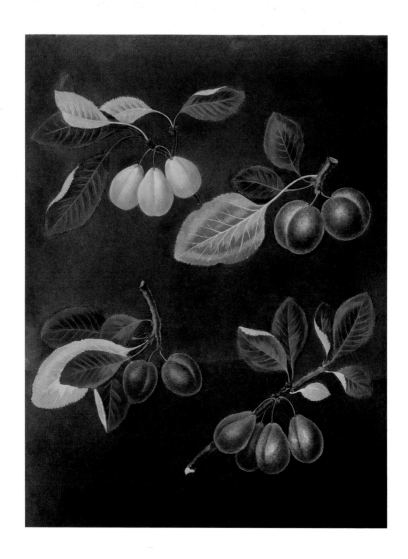

PLATE XV
— · Morroco Plum · Precos de Tour · Purple Hâtive
— · Königspflaume aus Tours · Frühpflaume aus Tours · Frühe Rote Kaiserpflaume
— · Royale de Tours · Précoce de Tours · Impériale rouge hâtive

PLATE XVI
Drap d'Or · White Gage Plum · Blue Gage Plum · Green Gage
Goldpflaume · Weiße Reneklode (Durchsichtige Reneklode) · Blaue Reneklode · Große Grüne Reneklode
Prune de drap d'or · Prune transparente · Reine-Claude violette · Reine-Claude

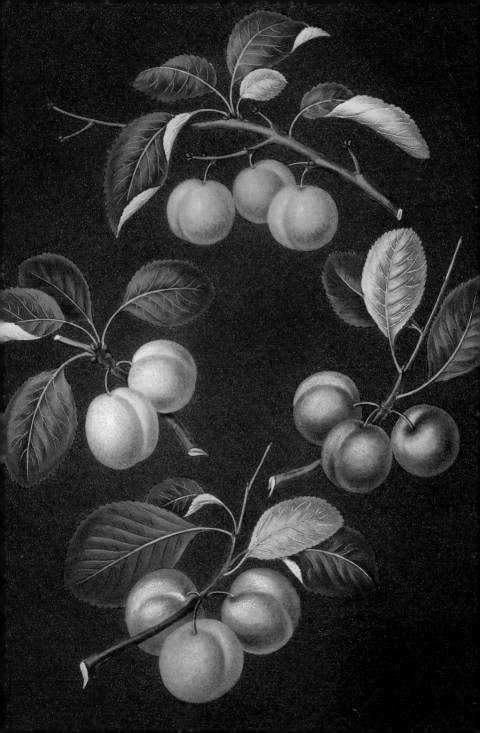

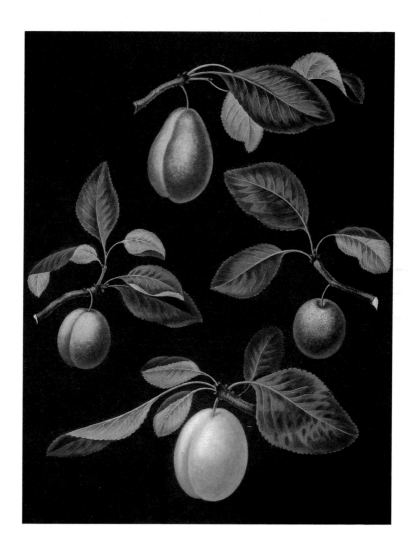

PLATE XVII

Red Magnum Bonum · Blue Perdrigon Plum · Le Royal Plum · White Magnum Bonum
Rote Eierpflaume · Violetter Perdrigon · Wahre Königspflaume · Gelbe Eierpflaume
Prune de Chypre (Dame Aubert rouge) · Perdrigon violet · Prune royale · Dame Aubert blanche

PLATE XVIII

Semiana Plum (Italian Prune) · Coe's Golden Drop Plum · White Perdrigon · Carboon Plum
Italienische Zwetschge (Fellenberger) · Coes Golden Drop · Weißer Perdrigon · Rote Diapre (Glühende Kohle)
Altesse double · — · Perdrigon blanc · Diaprée rouge

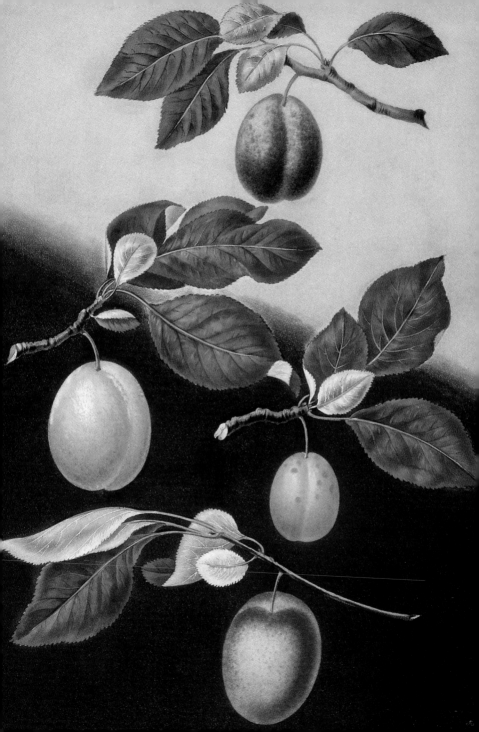

PLATE XXI
Pear Plum · Blue Imperatrice · — · Brignole · St. Catharine
Weiße Birnpflaume · Blaue Kaiserin · — · Herrnpflaume · Gelbe Katharinenpflaume
Prune poire · Impératrice · — · Brignole (Monsieur Violet) · Prune de Sainte Catherine

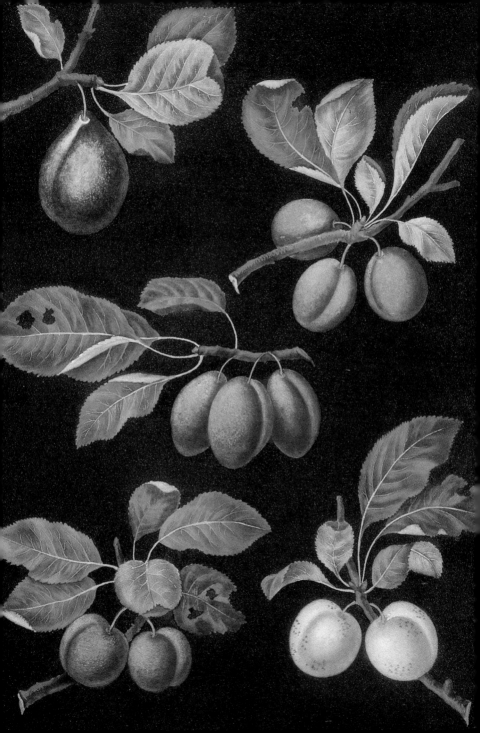

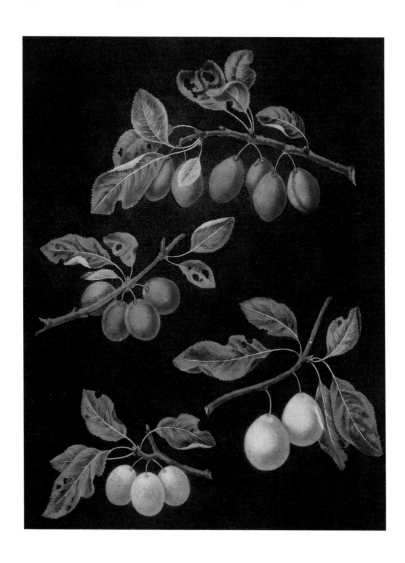

PLATE XXII
Common Damson · — · White Damson · —
Damaszenerpflaume · — · Kleine Weiße Damaszenerpflaume · —
Damas · Petite Damas blanc · —

PLATE XXIII
Carnation Plum · — · Wine Sour Plum · Dauphine Plum
Carnation · — · Saure Weinpflaume von Yorkshire · Dauphinspflaume
— · — · Vincuse de Yorkshire · Reine-Claude ancienne (Prune Dauphine)

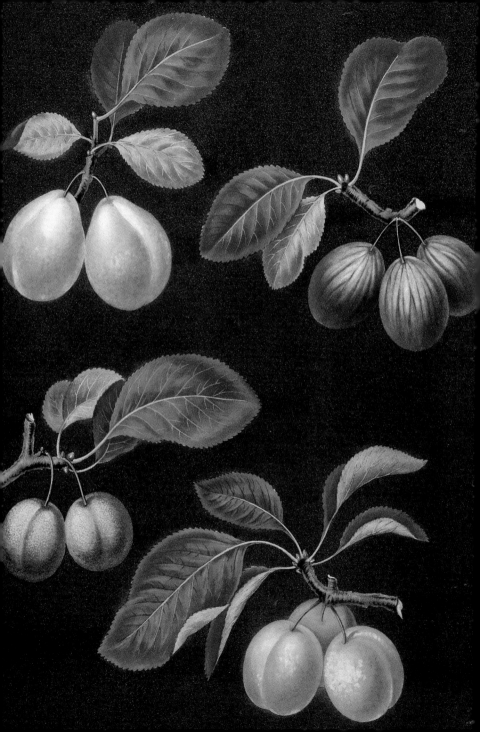

APRICOTS
Aprikosen | Abricots

The botanical name *Prunus armeniaca* is geographically misleading since the true home of the apricot is not Armenia but much further to the east, in Manchuria and northern China. From there it moved westward to the Near East and thus into the vicinity of Persia and Armenia. They called it *praikokia* or *praecoquia* – "precocious" – because it ripens early in the year, and through the vagaries of language it later acquired its initial A to become known by its current name. The apricot first traversed the Alps with the Romans but the Moors in Spain also saw to its cultivation and from there the relatively small tree arrived in French gardens during the 15th century. Even so, the apricot remained a quite insignificant fruit until the 18th century. Not even its botanical classification was clear and, despite its distinct flavour, it was considered a variety of peach. The stones of some varieties are bitter-tasting and were – and sometimes still are – used as an almond substitute: in Austria the apricot is customarily known as *Marille*, from the Latin for bitter, *amarus*.

Ihr botanischer Name, *Prunus armeniaca*, führt geographisch auf einen Umweg, denn die eigentliche Heimat der Aprikose liegt nicht in Armenien, sondern sehr viel weiter östlich, in der Mandschurei und im Norden Chinas. Von dort kam sie nach Westen bis in den Vorderen Orient und damit auch in das persisch-armenische Gebiet. Wegen ihrer frühen Reifezeit wurde sie „praikokia" und „praecoquia" genannt, was später auf verschlungenen Wegen und mit vorgesetztem A zum heute gebräuchlichen deutschen Namen führte. Daneben ist insbesondere in Österreich auch die Bezeichnung „Marille" gebräuchlich. Durch die Römer kam die Aprikose erstmals über die Alpen, aber auch die Mauren sorgten später in Spanien für ihren Anbau und von dort gelangte der relativ kleine Baum im 15. Jahrhundert auch in französische Gärten. Trotzdem blieb die Aprikose als Obst bis ins 18. Jahrhundert ziemlich bedeutungslos, zumal man sich über ihre botanische Einordnung zuerst nicht im Klaren war und sie trotz des unterschiedlichen Geschmacks für eine Pfirsichart hielt. Die bei manchen Sorten bitter schmeckenden Steine wurden und werden vereinzelt als Mandelersatz verwendet.

Son nom botanique, *prunus armeniaca*, nous induit en erreur sur sa véritable origine géographique, qui n'est pas l'Arménie mais se situe beaucoup plus à l'est, en Mandchourie et au nord de la Chine. De là, l'abricot a progressé vers l'Occident jusqu'au Proche-Orient, en passant par la Perse et l'Arménie. A cause de sa maturité précoce, il fut appelé «praikokia», et «praecoquia», ce qui a conduit, par déformations successives et positionnement de la lettre «A» en début de mot, au nom français actuel. En Autriche, on trouve aussi la désignation de «marille». Avec les Romains, l'abricot a franchi les Alpes. Les Maures l'ont implanté par la suite en Espagne, d'où cet arbre, relativement petit, a gagné les jardins français du XV^e siècle. Jusqu'au XVIII^e siècle, l'abricot n'a pas suscité un grand intérêt alimentaire, dans la mesure où l'on ne savait pas dans quelle catégorie botanique le classer et qu'on le tenait plutôt pour une variété de pêche, malgré son goût fort différent. Les noyaux qui, chez certaines variétés, ont un goût amer, étaient et sont encore parfois utilisés à la place de l'amande.

PLATE XIX
White Masculine · Red Masculine · Orange Apricot · Turkish Apricot
Kleine Weiße Frühaprikose · Frühe Muskateller-Aprikose · Orangen-Aprikose · Türkische Aprikose
Abricot blanc · Abricot hâtif musqué · Orange précoce · Gros abricot

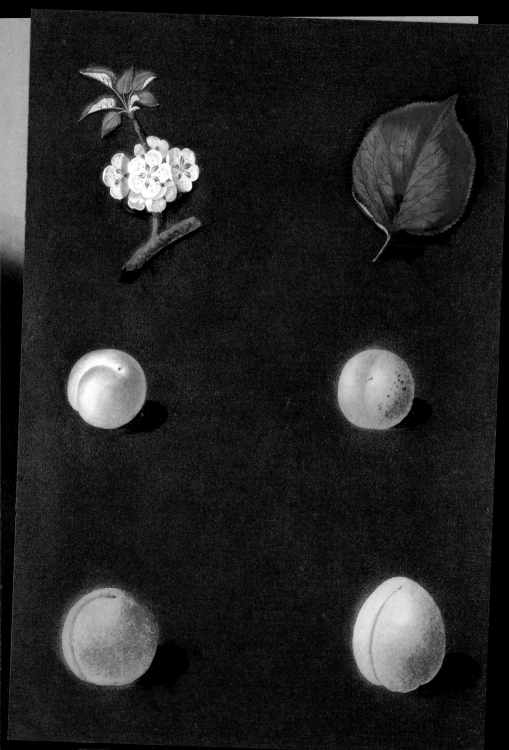

PEACHES · NECTARINES

Pfirsiche · Nektarinen | Pêches · Nectarines

Although its botanical name *prunus persica* points to Persia, in reality the peach originates from China and picked up the name on a stopover along its way west, whence the Romans came to know and appreciate it.
In the 17th century peaches crossed the Atlantic and encountered very good growing conditions on American soil. Consequently, in our times, the USA has become the main producer on the world market, with the yellow-fleshed fruits the dominant variety. The white-fleshed varieties are a little more flavorful, but generally ripen later. They include the Bloody Peach, despite its striking name and dark-red, juicy pulp. A cross between peach and plum led to a hybrid of lasting importance, the very popular nectarine. Besides its somewhat firmer consistency owing to a lower water content, it differs from the dessert or fuzzy peach primarily by its smooth skin. Both nectarines and peaches have clingstone varieties, so called because the stone is difficult to separate from the flesh. Once ripe, no varieties keep long and they are particularly susceptible to bruising.

Sein botanischer Name *prunus persica* deutet zwar auf Persien hin, in Wirklichkeit stammt der Pfirsich jedoch aus China und behielt lediglich auf seiner Wanderung Richtung Westen den Namen dieser Durchgangsstation bei, auf der ihn auch die Römer kennen und schätzen lernten.
Im 17. Jahrhundert übersprang der Pfirsich den Atlantik. Da ihm Amerika sehr gute Wuchsbedingungen bot, wurden die USA in unserer Zeit zu einem der wichtigsten Produzenten des Welthandels, auf dem die gelbfleischigen Früchte dominieren. Noch etwas geschmacksintensiver sind die weißfleischigen Sorten, die allerdings zumeist später reifen. Zu ihnen zählt, dem Namen zum Trotz, auch der Blutpfirsich, der nicht nur mehr Saft führt, sondern in erster Linie durch sein dunkelrot gefärbtes Fruchtfleisch verblüfft. Von nachhaltiger Bedeutung erwies sich die Kreuzung des Pfirsichs mit der Pflaume, die zur heute sehr beliebten Nektarine führte. Neben einem etwas festeren, weil wasserärmeren Fruchtfleisch unterscheidet sie sich vom Edel- oder Pelzpfirsich vor allem durch ihre glatte Fruchthaut. Diese hat sie auch mit den aromatischen Brugnolen gemeinsam, deren Stein sich allerdings nur schwer vom Fruchtfleisch löst, eine Eigenschaft, die diese mit den Pfirsich-Härtlingen, auch Duranzen genannt, teilen. Im reifen Zustand sind alle Sorten nur sehr beschränkt haltbar und vor allem sehr druckempfindlich.

Sa dénomination botanique *prunus persica* renvoie à la Perse, mais en réalité, la pêche est originaire de Chine et n'a gardé dans son nom que le souvenir d'une étape de son voyage vers l'Occident. C'est toutefois en Perse que les Romains ont appris à la connaître et à l'apprécier.
Au XVIIe siècle, la pêche traverse l'Atlantique et trouve d'excellentes conditions de croissance en Amérique. Aujourd'hui, les Etats-Unis sont devenus l'un des plus importants producteurs de pêche au monde, les variétés à chair jaune étant les plus représentées. Celles à chair blanche ont un goût plus intense mais mûrissent généralement plus tard. Curieusement, on compte parmi elles la pêche sanguine, plus juteuse, qui fascine par sa chair d'un rouge profond. Le croisement de la pêche avec la prune a donné la nectarine, très appréciée aujourd'hui. Elle se distingue de la pêche à la peau veloutée par une chair un peu plus ferme, car moins gorgée d'eau, et surtout par sa peau lisse. C'est une caractéristique qu'elle partage avec le brugnon, très parfumé, mais dont le noyau se détache difficilement de la chair, comme c'est aussi le cas de la pêche dure, ou durance. Une fois mûres, toutes ces sortes souffrent d'une durée de conservation limitée et surtout, sont très sensibles aux chocs.

PLATE XXIV
Red Nutmeg · Hemskirk Peach · — · —
Kleiner Roter Frühpfirsich · Pfirsch von Hemskirk — · —
Avant pêche rouge · — · —

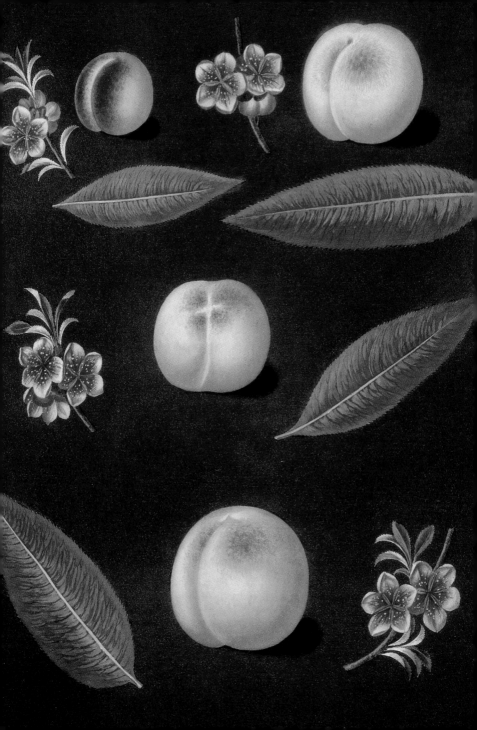

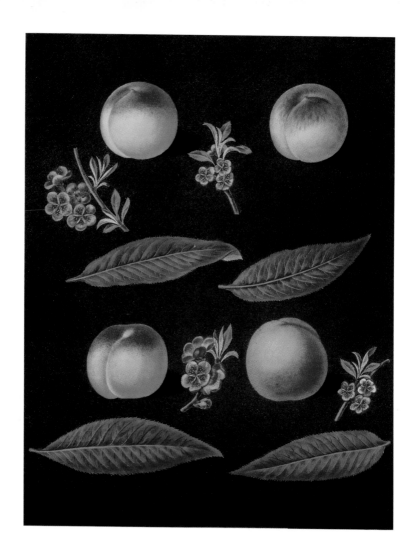

PLATE XXV
White Avant Peach · Bears Red Avant · White Magdalen · Red Magdalen
Kleiner Weißer Frühpfirsich · Früher Purpurpfirsich · Weißer Magdalenen-Pfirsich · Roter Magdalenen-Pfirsich
Avant blanche · Avant rouge · Madeleine blanche (Montagne blanche) · Madeleine rouge (Madeleine de Courson)

PLATE XXVI
Grimwood's Royal George Peach · Grimwood's Royal Charlotte Peach · French Mignonne
Grimwoods Königliche Magdalene · Mittelgroßblühende Magdalene · Gemeiner Lieblingspfirsich (Lackpfirsich)
Madeleine rouge · Madeleine hâtive · Mignonne ordinaire

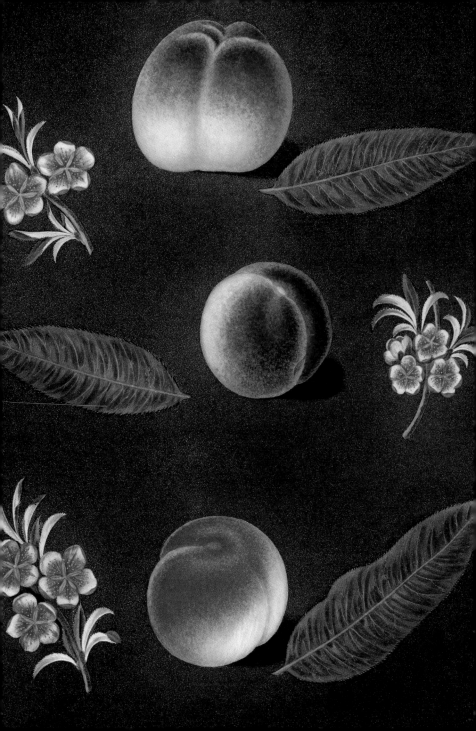

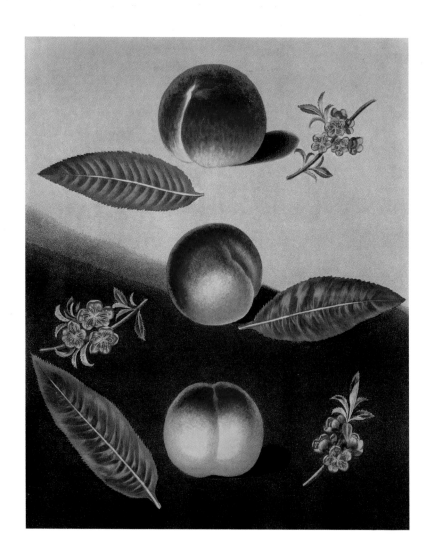

PLATE XXVII
Early Purple Peach · Peach of Mr. Padley's · Galand Peach (Violet Hâtive Peach)
Früher Purpurpfirsich · Peach of Mr. Padley's · Violette Galande
Pourprée hâtive · Peach of Mr. Padley's · Violette hâtive

PLATE XXVIII
Early Newington Peach · Buckinghamshire Mignonne · Mignonne Barrington Peach
Früher Newington (Frühe Dunkelrote Nektarine) · Mignon-Pfirsich von Buckinghamshire · Barringtoner Lieblingspfirsich
Nectarine de Newington · Mignonne de Buckinghamshire · Pêche de Barrington

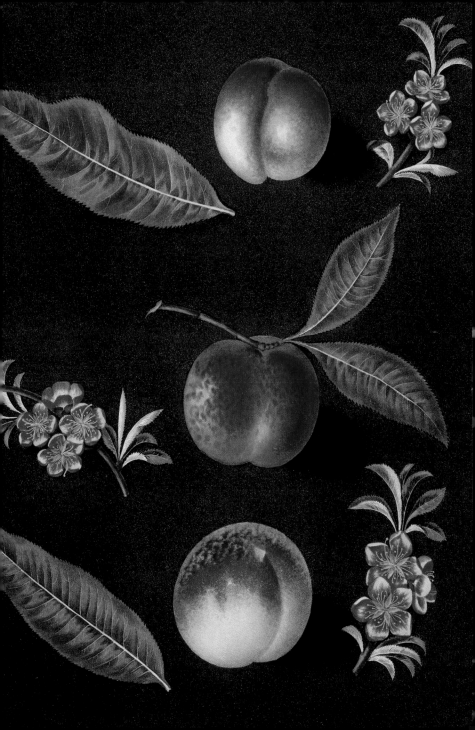

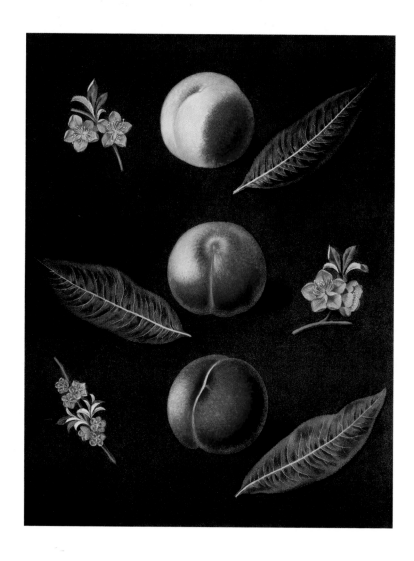

PLATE XXIX
Montauban Peach · Gross Minion · Royal George Old Peach
Bergpfirsich · Großer Lieblingspfirsich (Lackpfirsich, Großer Prinzessinpfirsich) · Königspfirsich Old George
La Montauban · Grosse mignonne (Veloutée de Merlet) · Royal George Old Peach

PLATE XXX
Millet's Minion Peach · Superb Royal · Double Swalsh
Königlicher Magdalenen-Pfirsich · Ausgezeichneter Königspfirsich · Königliche Magdalene
Millets mignonne · Royale superbe · Madeleine rouge

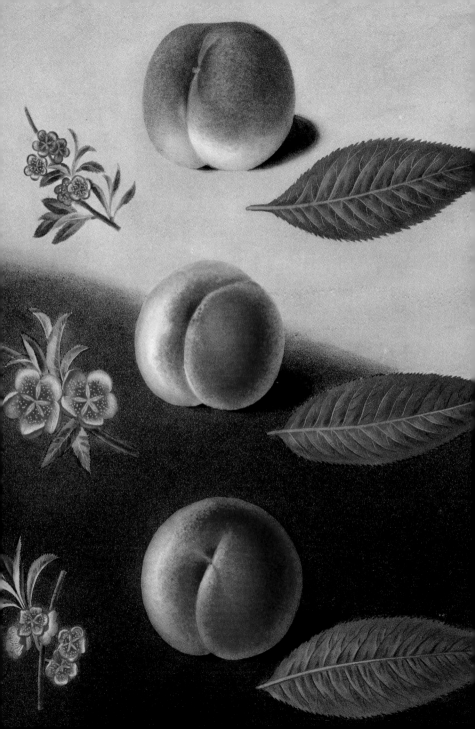

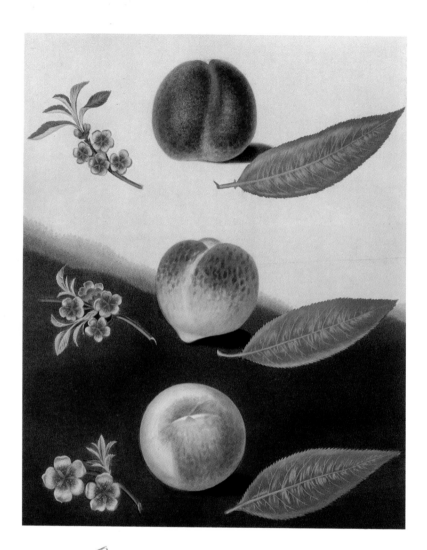

PLATE XXXI
Gallande · — · Noblesse Peach
Schöne Wächterin · — · Edle Magdalene
Pêche galande (Bellegarde) · — · Noble pêche

PLATE XXXII
Marlborough Peach · Rombullion Peach · Double Mountain Peach
Marlborough-Pfirsich · Rombullion-Pfirsich · Doppelte Montagne (Großer Bergpfirsich)
Pêche de Marlborough · Rombullion · Double montagne (Montagne précoce la grosse)

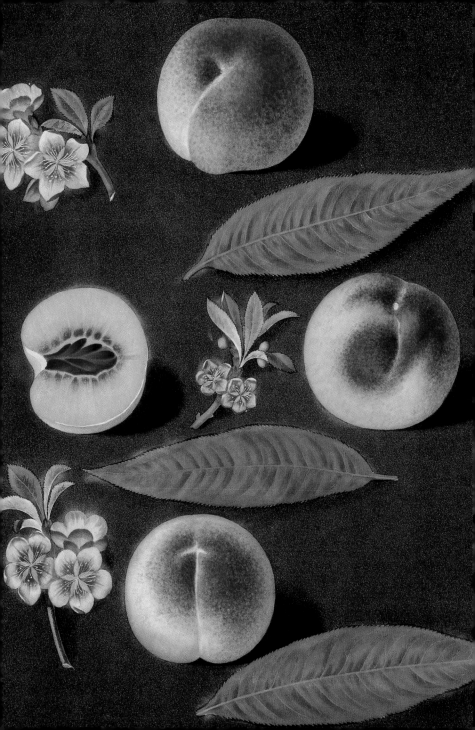

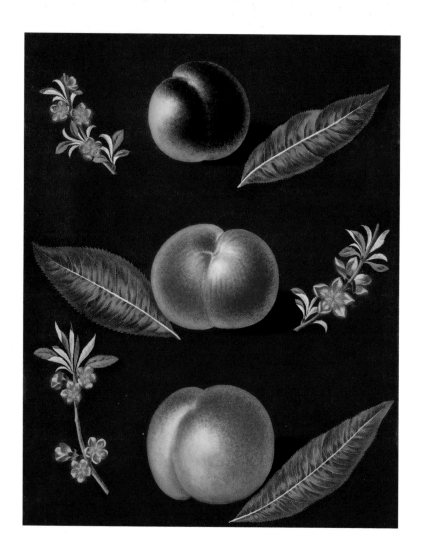

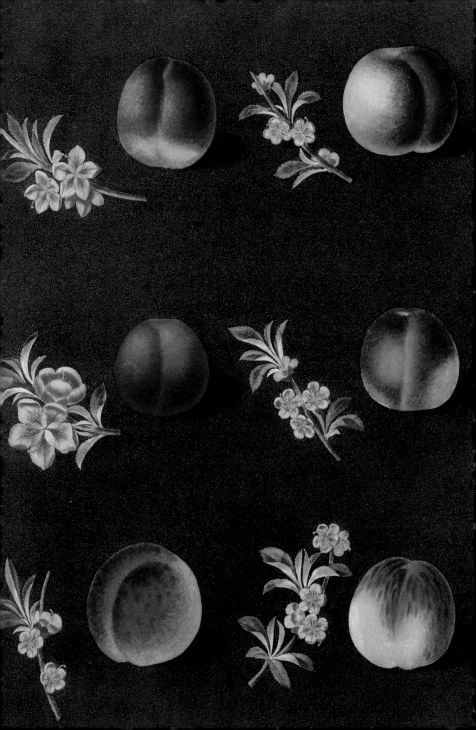

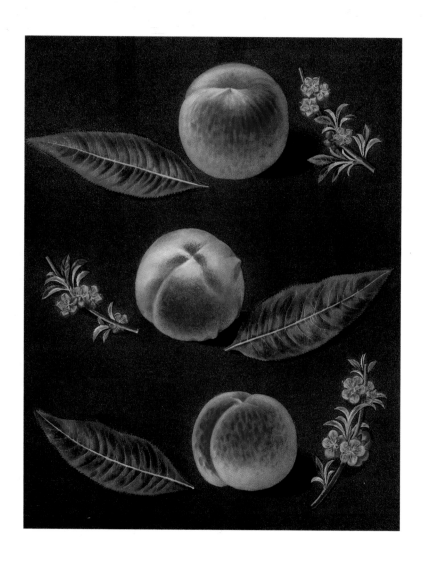

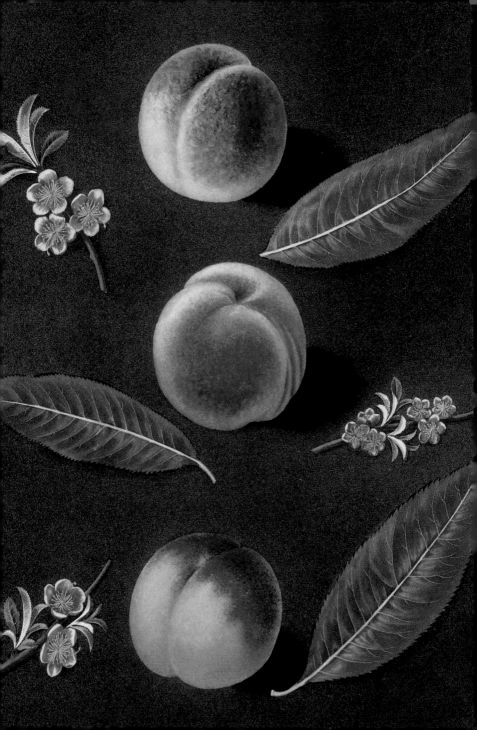

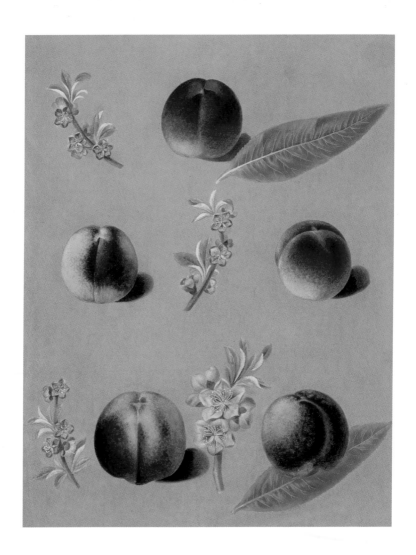

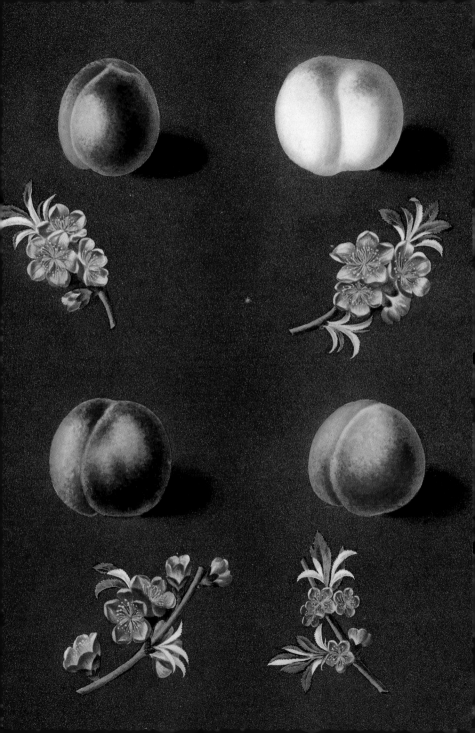

PINEAPPLES

Ananas | Ananas

Christopher Columbus and his sailors were the first Europeans to become acquainted with pineapples. When they landed on Guadeloupe in 1493, they received these spiny fruits originally native to Brazil as a gift from their hosts. Brought to the court of King Ferdinand and Queen Isabella in Spain, they delighted Their Majesties not only with their unusual appearance, but particularly with their unique flavour.

It was relatively simple to cultivate, since a new plant could be raised with little effort from the severed crown, which could be brought to fruitbearing maturity even in the hothouses of central Europe. The breakthrough for pineapples as a product on the global market came at the end of the 19th century when they were conserved, ready to eat, in cans. Canning was instituted in Singapore in 1888, in Hawaii in 1892, and in Formosa in 1902. The Ginaca machine, developed in 1913 in Hawaii, soon enabled fully automated peeling and coring of the pineapple, and the fleshy cylinder could then be sliced or cut into chunks as desired. Today this tropical fruit is dispersed worldwide and is available at a reasonable price. Nevertheless, the opinion that Michael Friedrich Lochner expressed in 1714 still applies: the pineapple "should be called a queen of the fruits, which embraces all the delights of the palate."

Christoph Columbus und seine Matrosen waren die ersten Europäer, die die Ananas kennen lernten. Als sie 1493 auf Guadeloupe landeten, erhielten sie die ursprünglich in Brasilien beheimateten stacheligen Früchte als Gastgeschenk. Nach Spanien an den Hof König Ferdinands gebracht, erregten sie durch ihr ungewöhnliches Aussehen und ihren unvergleichlichen Geschmack das Wohlgefallen der Majestäten.

Der Anbau war relativ einfach möglich, denn aus der abgetrennten Krone ließ sich mit geringem Aufwand eine neue Pflanze ziehen, die auch in Mitteleuropa in Treibhäusern zur Fruchtreife gebracht werden konnte. Der Durchbruch der Ananas als Weltwirtschaftsgut begann am Ende des 19. Jahrhunderts, als man sie 1888 in Singapur, 1892 auf Hawaii und 1902 auf Formosa essfertig in Dosen konservierte. Die 1913 auf Hawaii entwickelte Ginaca-Maschine erlaubte bald die vollautomatische Schälung und Entkernung der Ananas, deren zylindrisch zugeschnittenes Fruchtfleisch nach Wunsch in Scheiben oder Stücke zerteilt werden konnte. Heute ist die tropische Frucht weltweit verbreitet und zum preiswerten Obst geworden, aber immer noch gilt Michael Friedrich Lochners 1714 geäußerte Meinung, die Ananas sei „eine Königin der Früchte zu nennen, in welche alle Lustreizungen des Geschmacks versenket".

Christophe Colomb et ses matelots furent les premiers Européens à découvrir l'ananas. Lorsqu'ils débarquèrent en Guadeloupe en 1493, ce fruit écailleux, originaire du Brésil, leur fut offert en cadeau d'accueil. A la Cour du roi Ferdinand d'Espagne, l'aspect insolite de l'ananas, et surtout sa saveur incomparable, surent plaire à Leurs Majestés.

Il suffisait de couper la touffe de feuilles à son sommet pour faire naître une nouvelle plante qui mûrissait même dans les serres d'Europe centrale. L'ananas s'imposa véritablement sur le marché mondial à la fin du XIXe siècle, à partir du moment où l'on sut le conserver en boite, prêt à être consommé: en 1888 à Singapour, en 1892 à Hawaii et en 1902 à Formose. Bientôt, la machine Ginaca, développée à Hawaii en 1913, en automatisa complètement l'épluchage et l'évidage. Sa chair, taillée dans une forme cylindrique par la machine, pouvait ensuite être découpée en rondelles ou en morceaux, selon les besoins. Aujourd'hui, ce fruit tropical est répandu dans le monde entier à un prix abordable. Mais l'opinion émise en 1714 à son sujet par Michael Friedrich Lochner reste encore valable. Il faut, disait-il, « l'appeler roi des fruits, tant se fondent en lui toutes les jouissances du palais ».

PLATE XL
Black Jamaica Pine
—
—

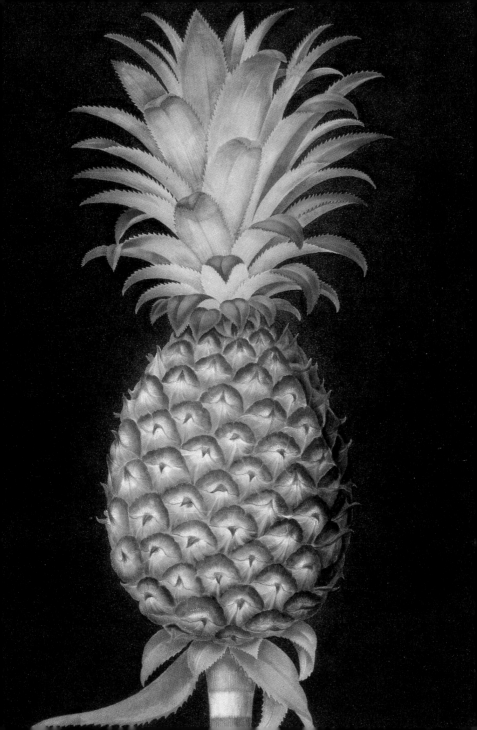

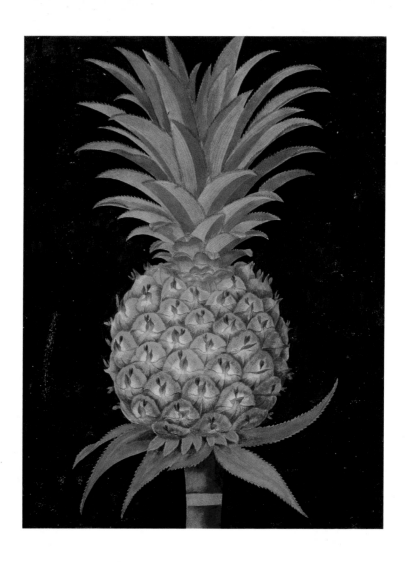

PLATE XLI
Riply Pine
—
—

PLATE XLIII
Brown Havannah Pine
—
—

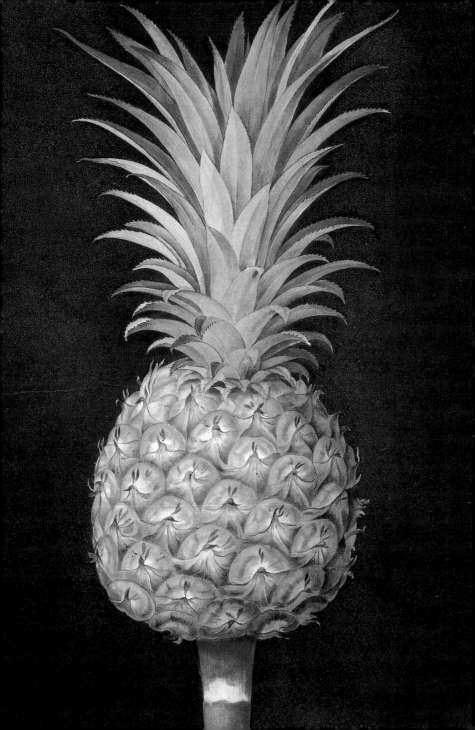

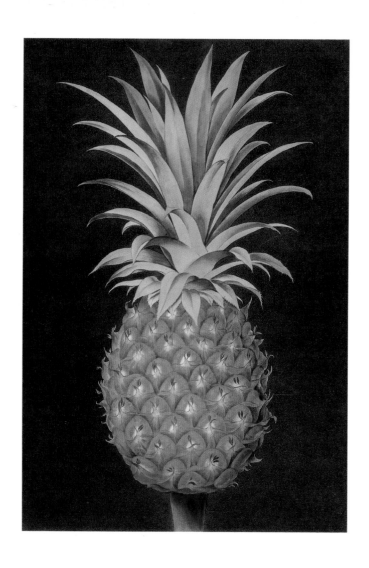

PLATE XLIV
Smoothe Leaved Green Antigua Pine
—
—

PLATE XLV
Jagged Leaf Black Antigua
—
—

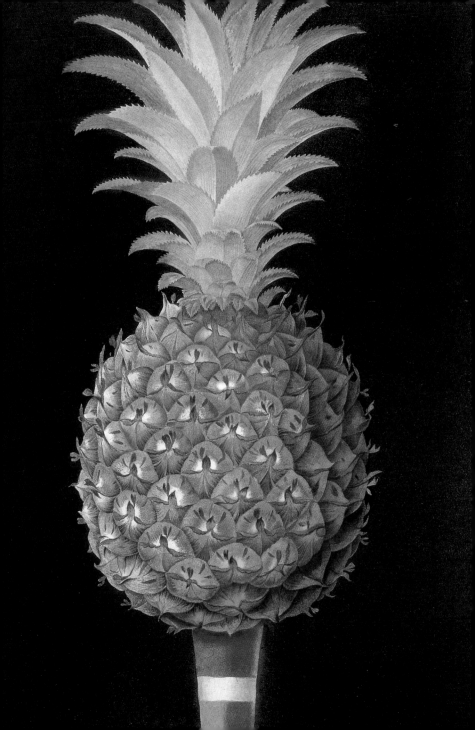

GRAPES
Trauben | Raisins

The breeding of grapes pursues different goals, depending on whether they are destined for the wine-press or the dessert-bowl. What matters for wine grapes is the taste and bouquet that the fruits give to the finished wine. Dessert grapes, on the other hand, must pay equal tribute to the eye and the palate: attractive, plump clusters, preferably seedless and tender-skinned and, of course, full of flavour.

Back to the beverage grapes: for at least 6000 years mankind has known how to prepare grape juice so as to allow yeast to ferment the sugar into alcohol. The wine produced then probably tasted quite different from what we are used to today, but it was evidently quite popular in Asia Minor and in Egypt, for example, and also created much demand among the Greeks. Their characteristic resin-flavoured wine, *retsina*, is still liked to this day. The Romans spread viticulture throughout Europe. Even the Church played an important role during medieval times, since Jesus' words, "I am the vine, ye are the branches" (John 15,5) elevated the plant to a symbolic importance that explains its intense cultivation in monasteries. But it was only in the 18th century that viticulture as we now know it was gradually developed.

Die Züchtung der zum Keltern bestimmten Reben und der Tafeltrauben verfolgt verschiedene Ziele. Bei den Wein-Trauben kommt es allein auf den Geschmack an, den die Früchte dem fertigen Wein verleihen. Bei den Tafeltrauben aber fordern Auge und Zunge gemeinsam ihren Tribut: imponierendes Aussehen, möglichst Kernlosigkeit, eine zarte Schale und natürlich das Aroma sind hier gleichermaßen gefragt.

Zurück zu den getrunkenen Trauben: Seit mindestens 6000 Jahren ist der Mensch in der Lage, mit dem Traubensaft so zu verfahren, dass dessen Zucker der Hefe Gelegenheit zur alkoholischen Gärung gibt. Der damals entstandene Wein schmeckte zwar sicherlich ganz anders, als wir dies heute gewöhnt sind, er fand aber zum Beispiel im Vorderen Orient und in Ägypten offenbar viele Anhänger und auch die Griechen sprachen ihm gerne zu. Ihr charakteristisch geharzter Wein, der Retsina, ist bis heute beliebt. Mit den Römern verbreitete sich der Rebanbau in Europa. Im Mittelalter spielte nicht zuletzt auch die Kirche eine wichtige Rolle, denn das Jesuswort „ich bin der Weinstock, ihr seid die Reben" (Joh. 15,5) erhebt die Pflanze zu besonderer symbolischer Bedeutung und macht ihre starke Kultur in den Klöstern verständlich. Erst im 18. Jahrhundert beginnt aber nach und nach der Ausbau der Weine auf die uns heute bekannte Weise.

La culture du raisin suit un objectif différent, selon qu'il est destiné au pressoir ou à la table. Pour le raisin de vin, seul compte le goût que le fruit communiquera à la boisson. Mais en ce qui concerne le raisin de table, l'œil et le palais ont tous deux leurs exigences: belle apparence, pépins aussi peu sensibles que possible, peau fine et bien sûr parfum adapté.

Revenons au raisin transformé en boisson. Depuis au moins 6000 ans, l'homme sait en tirer un jus dont le sucre produit une fermentation alcoolique en présence de levure. Les vins de l'époque avaient certainement un tout autre goût que celui auquel nous sommes habitués aujourd'hui, mais ils trouvaient manifestement beaucoup d'adeptes au Proche-Orient et en Egypte, et les Grecs aussi leur faisaient honneur. Leur vin résineux caractéristique, la retsina, est encore apprécié aujourd'hui. Avec les Romains, la culture de la vigne se répandit en Europe. Au Moyen Age, l'Eglise joua un rôle important. Car la parole de Jésus « Je suis le cep; vous êtes les sarments » (Jean 15,5) a donné à cette plante une signification symbolique particulière et explique que sa culture soit très répandue dans les couvents. L'extension de la vigne, telle que nous la connaissons aujourd'hui, ne commence toutefois qu'au XVIIIᵉ siècle.

PLATE XLVII
Reasin de Calmes
Reasin de Calmes
Raisin de Calmes

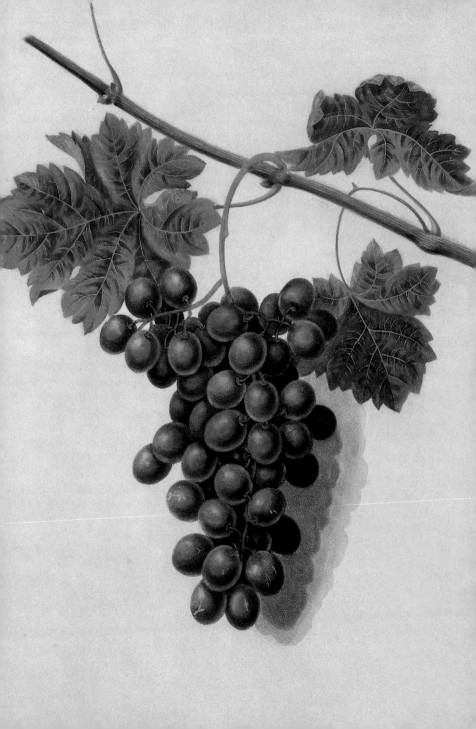

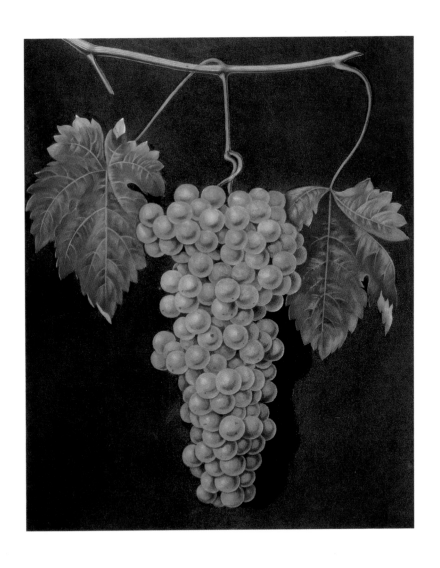

PLATE XLVIII
Royal Muscadine Grape
Weißer Gutedel (Gemeiner Gutedel)
Chasselas

PLATE XLIX
Blue Muscadine Grape
Blauer Gutedel (Königs-Gutedel)
Chasselas violet

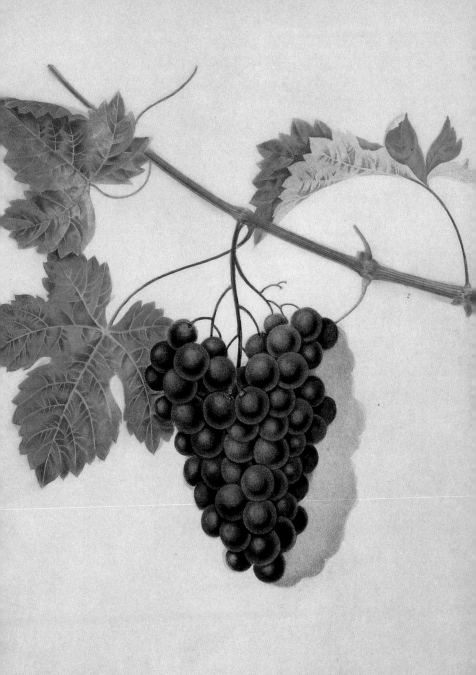

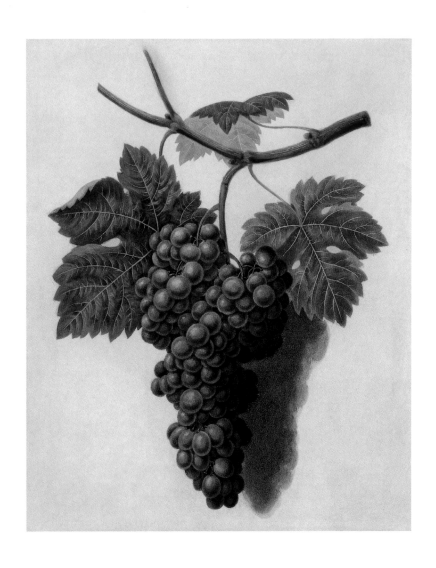

PLATE L
Black Muscadine Grape
Schwarzer Muskat-Gutedel
Chasselas noir

PLATE LI
Black Marocco (Morocco Grape)
Große Maroccaner
Raisin du Maroc

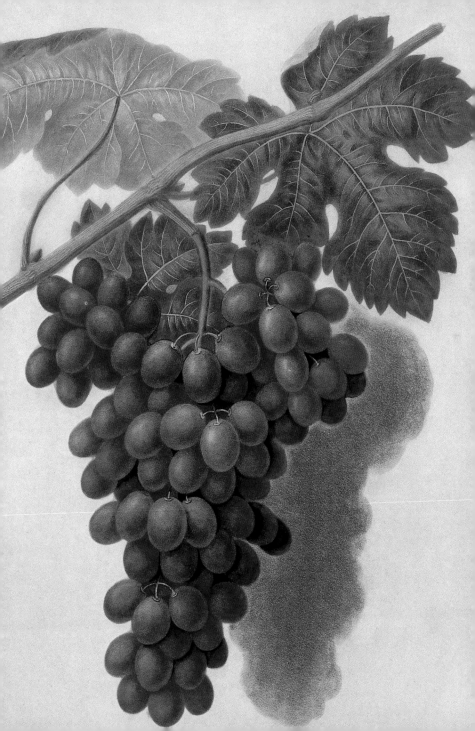

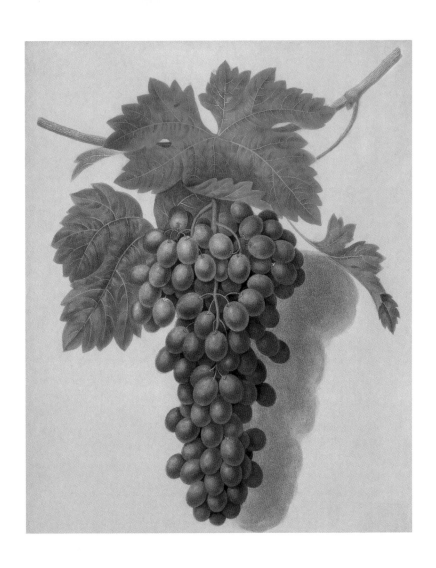

PLATE LII
Black Prince Grape

—

—

PLATE LIII
Muscat of Alexandria
Muskat-Damaszener
Muscat d'Alexandrie

8o

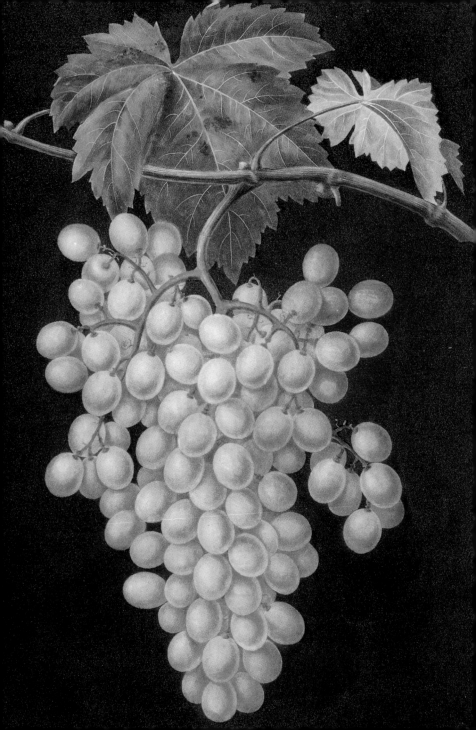

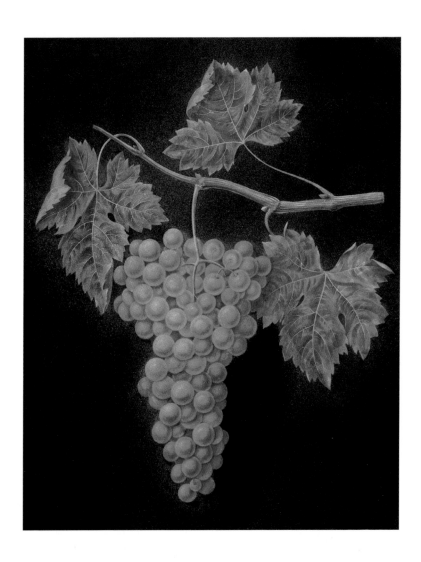

PLATE LIV
White Frontiniac Grape
Gelber Muskateller
Frontignac blanc (Muscat blanc)

PLATE LV
Frontiniac Grizzly Grape
Grauer Muskateller
Frontignac gris (Muscat gris)

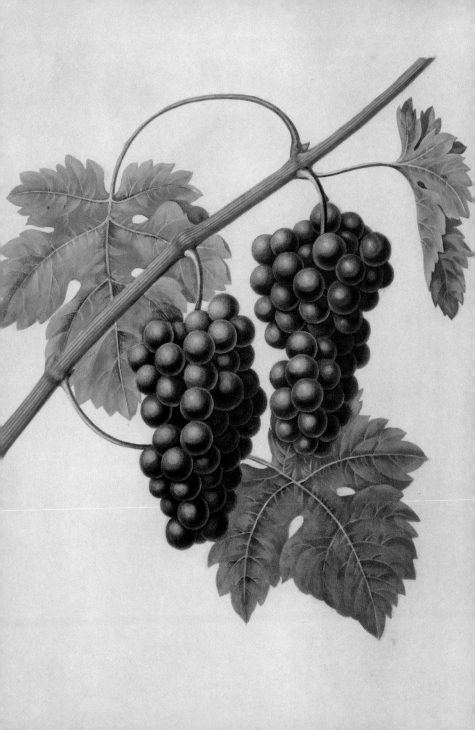

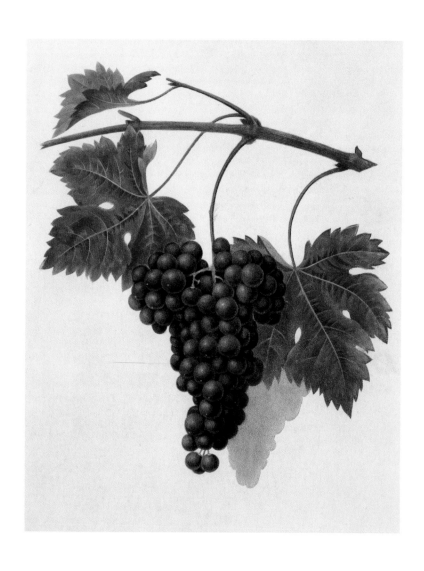

PLATE LVI
Red Frontiniac Grape
Roter Muskateller
Frontignac rouge (Muscat rouge)

PLATE LVII
Black Frontiniac Grape
Schwarzer Muskateller
Frontignac noir

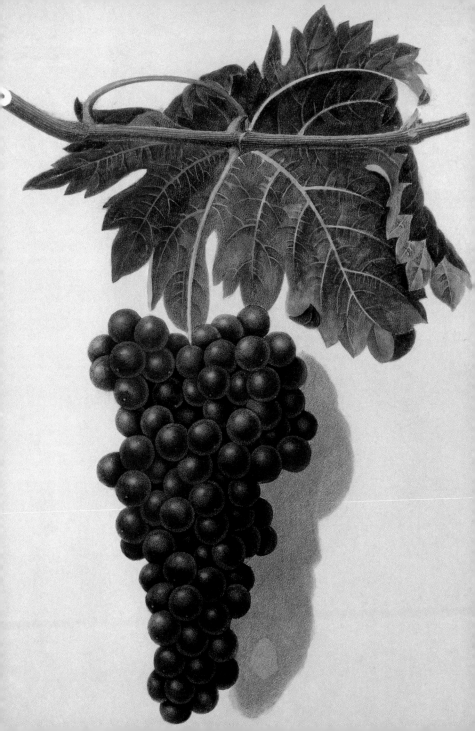

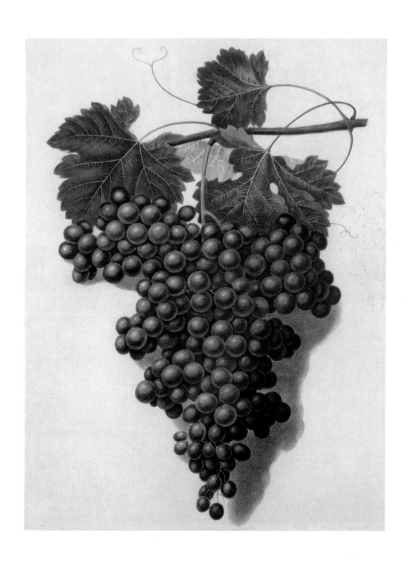

PLATE LVIII
Old St. Peter Grape
Old St. Peter
—

PLATE LIX
Black Hamburgh Grape
Trollinger (Blauer Trollinger)
Grand noir

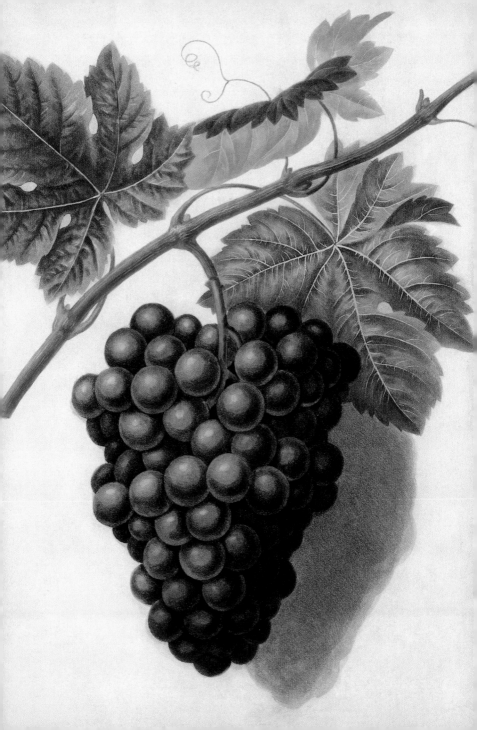

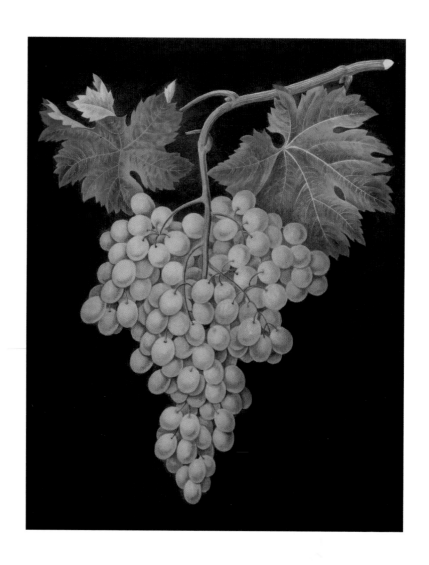

PLATE LX
White Hamburgh Grape
—
—

PLATE LXI
Grape Lady Bathurst Tokay
Ruländer (Grauer Burgunder)
Pinot gris

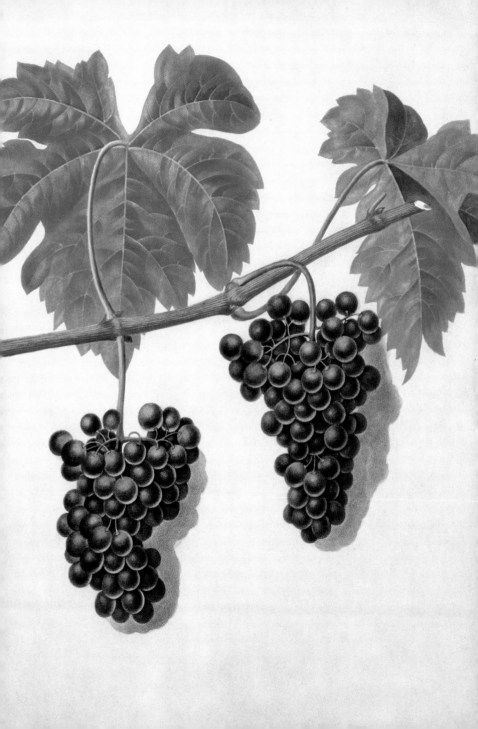

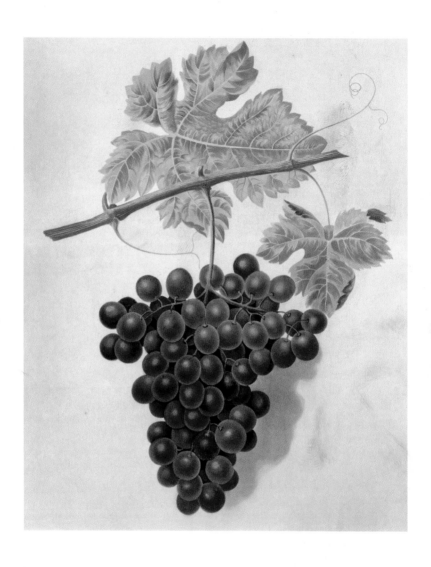

PLATE LXII
Frankindale Grape
Frankenthaler (Weißer Muskat-Gutedel)
Muscat chasselas

PLATE LXIII
White Sweet Water Grape
Diamant-Gutedel (Früher Gutedel)
Muscadin-Diamant

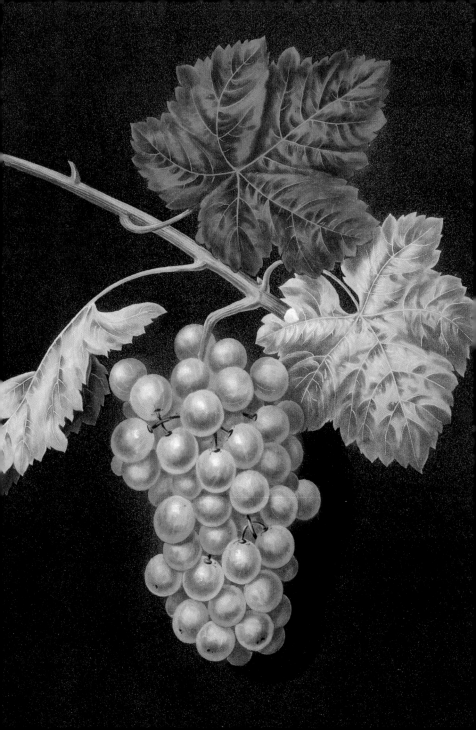

MELONS
Melonen | Melons

Although closely related to cucumbers, melons do not share their bitterness. Whether Muskmelon, Honeydew, or Netted Cantalope, all have a pleasant refreshing sweetness, even the less strongly flavoured Watermelon, which is botanically classed within another genus of the gourd family, originating from southern Central Africa, and was an early arrival to the Mediterranean region. *Citrullus*, the name it still carries today, probably derives from the Italian *citrullo*, meaning sap-head or dumbbell, mockingly drawing an analogy between these bloated giant fruits and the lack of substance of a simpleton's mind.

The Muskmelon, *Cucumis melo* L., and its varieties come from the Middle East and were likewise introduced early into the warmer climates of the Mediterranean, where they have been valued since olden days as a sweet thirst quencher and delicacy. The greater part of global production is from Asia, particularly China, Turkey and Iran, but the USA, Spain, Brazil and other countries are also important suppliers, and even some areas of Germany nurture the long trailers of these imposing fruits.

Zwar gehört die Gurke zu ihren nahen Verwandten, aber den herben Geschmack hat die Melone nicht mit ihr gemeinsam. Gleichgültig ob Zucker-, Honig-, Netz- oder Kantalup-Melonen: Ein angenehm erfrischender und süßer Geschmack ist ihnen allen zu eigen, sogar – wenn auch etwas schwächer – der Wassermelone. Letztere gehört botanisch zu einer anderen Gattung der Kürbisgewächse, stammt ursprünglich aus dem südlichen Zentralafrika, gelangte aber schon früh ins Mittelmeergebiet. Ihr noch heute gültiger lateinischer Name *Citrullus* leitet sich wohl vom italienischen „citrullo", Dummkopf, ab und vergleicht spöttisch die aufgeblasenen, riesigen Früchte und ihren wassertriefenden Inhalt mit dem vermeintlich ebenso substanzlosen Kopf eines einfältigen Menschen.

Die Zuckermelone, *Cucumis melo ssp. melo* L., und ihre Varietäten stammen aus dem mittelasiatischen Bereich und verbreiteten sich ebenfalls schon früh im warmen Klima der Mittelmeerländer, wo sie als süßer Durstlöscher und delikates Obst seit alters geschätzt werden. Der Großteil der Weltproduktion wird in Asien, insbesondere in China, der Türkei und dem Iran erzeugt, doch sind ebenso die USA, Spanien, Brasilien und andere Überseeländer wichtige Lieferanten, und sogar in einigen Gegenden Deutschlands reifen die stattlichen Früchte an den langen Ranken.

Proche parent du concombre, mais appartenant à une autre espèce de cucurbitacées, le melon n'en a pas le goût austère. Car quelle qu'en soit la variété – melon sucrin, melon d'eau, melon brodé ou cantaloup – il offre toujours un goût agréablement rafraîchissant et sucré, même quand il s'agit de pastèques, à la saveur moins prégnante. Originaire du sud de l'Afrique centrale, le melon d'eau s'est implanté tôt dans le bassin méditerranéen. Le nom latin de *citrullus* qu'on lui donne encore aujourd'hui provient probablement de l'italien « citrullo » (bêta en français). Sans doute ce fruit énorme et rond, gorgé d'eau, faisait-il penser à la tête d'un simple d'esprit, parfois grosse mais vide de substance.

Le melon sucrin, *cucumis melo ssp. melo* L. et ses variétés proviennent du Moyen-Orient et se sont tôt répandues sous le climat chaud du bassin méditerranéen où ce fruit délicat et suave étanche délicieusement la soif. La majeure partie de la production mondiale vient d'Asie, en particulier de Chine, de Turquie et d'Iran, mais aussi des Etats-Unis, d'Espagne, du Brésil et d'autres pays d'outre-mer, et même de certaines régions d'Allemagne l'on peut voir mûrir ces gros fruits au bout de leurs longues vrilles.

PLATE LXIV
Scarlet Fleshed Romana Melon
–

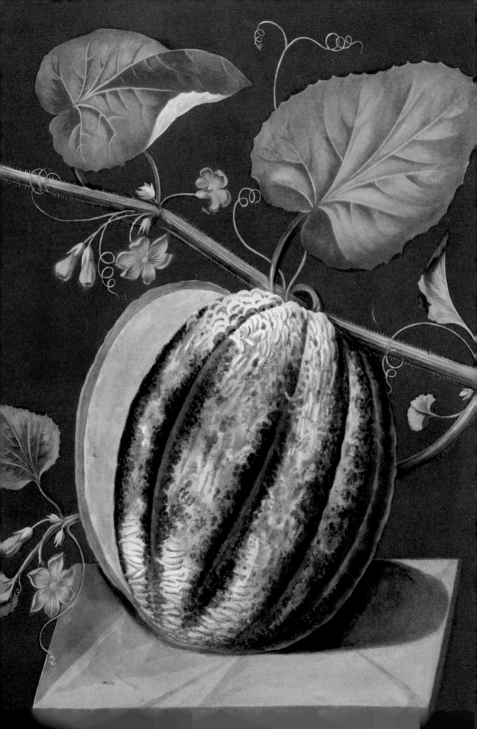

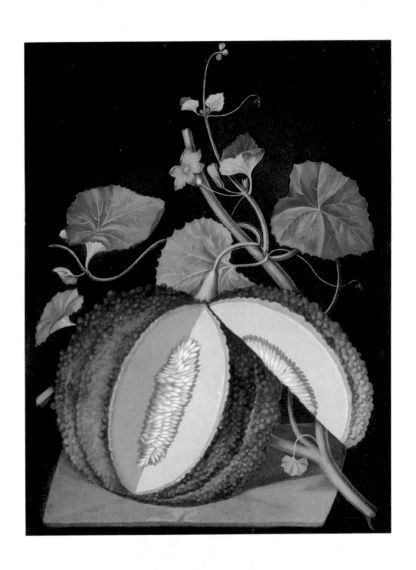

PLATE LXV
White-seeded Rock Melon
—
—

PLATE LXVI
Scarlet Flesh Rock Melon
—
—

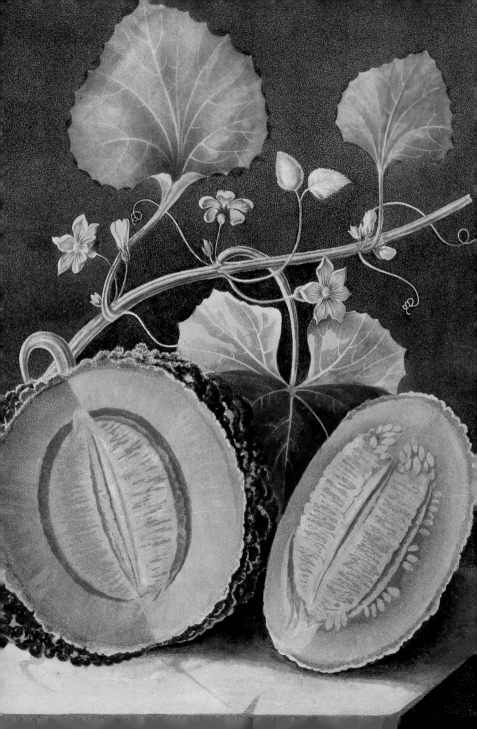

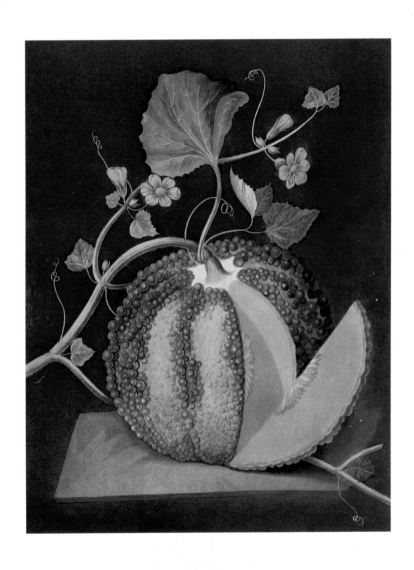

PLATE LXVII
Silver Rock Melon

—

—

PLATE LXVIII
Polignac Melon

—

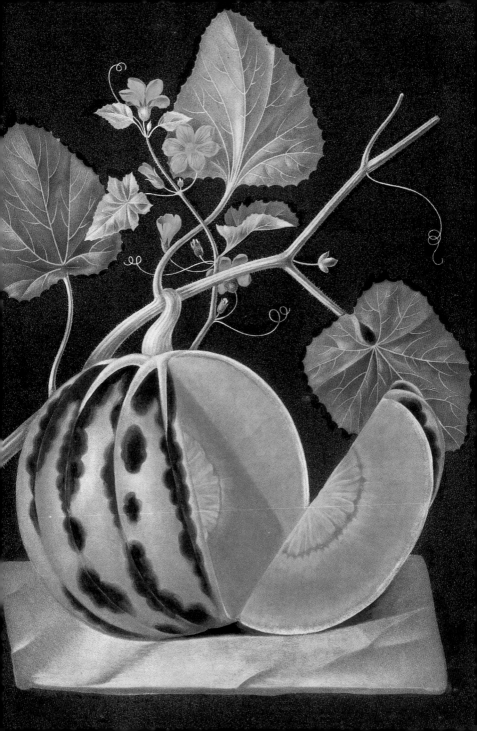

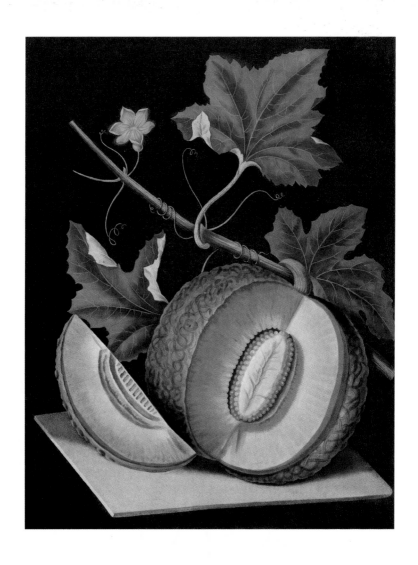

PLATE LXIX
Green flesh Melon
Grünfleischige Melone
—

PLATE LXX
Cantlope Melon
Kantalup-Melone
Melon de Florence

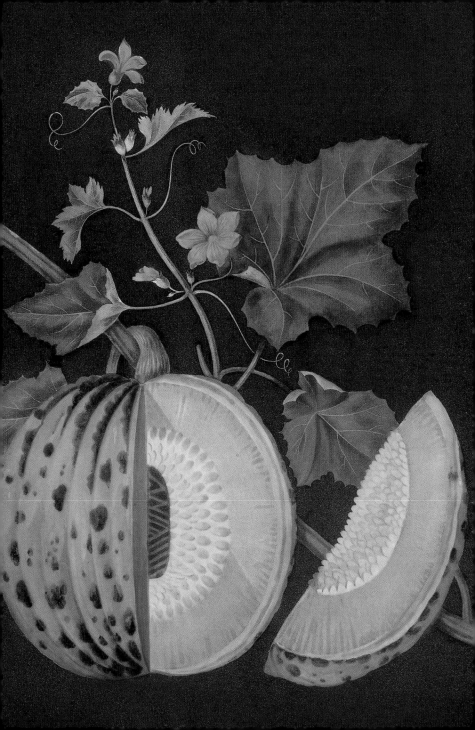

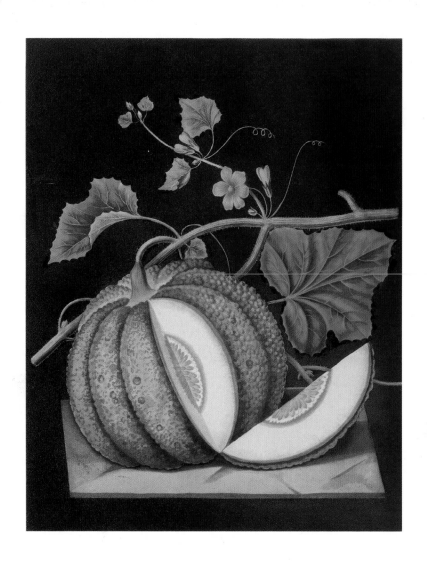

PLATE LXXI
White Claudia (White Flesh Melon)
—
—

PLATE LXXII
Amicua Melon
—
—

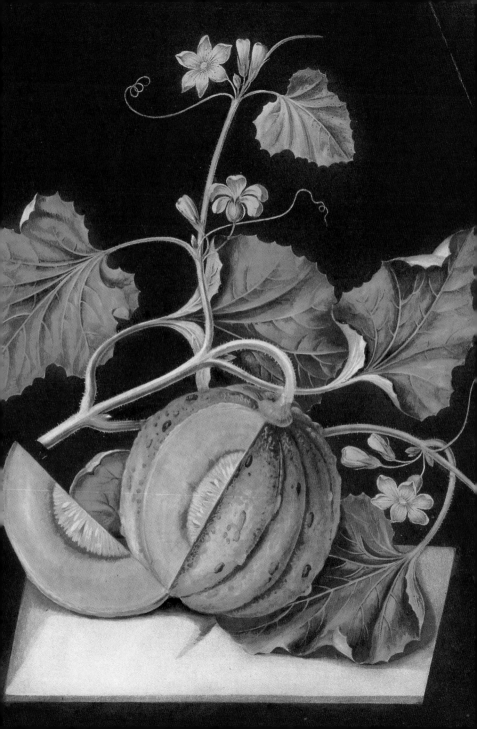

NUTS
Nüsse | Noisettes

In his *Historia naturalis* Pliny described the Hazelnut as the "Pontic nut", thus giving a clear indication of its origins in Asia Minor. From there it spread rapidly throughout Europe and made its way into our gardens during the Middle Ages, although for a long time it was gathered from bushes growing in the wild, which draw attention to themselves in the early spring with their yellow catkins. Although a pretty sight, it comes at the price of a bout of hayfever for those suffering from a pollen allergy. The twigs of the hazel bring us within the realm of myth and the esoteric, since a forked twig cut from a hazel bush was traditionally the preferred divining rod to detect all sorts of things, not just water. Besides the wild hazelnut varieties, only the nuts bred in the 16th century near Würzburg and Bamberg, the large Hazel or Cobnut and the little red Lambert (the name signals its Lombardian origins), play a role in today's marketplaces. At the end of the 18th century, the American Filbert was added to the European varieties and extensive crossing between all these related species resulted in the choice modern hybrids known since the 19th century.

In seiner *Historia naturalis* nennt Plinius die Haselnuss „Pontische Nuss" und gibt uns damit einen deutlichen Hinweis auf ihre ursprünglich kleinasiatische Herkunft. Schnell verbreitete sie sich aber über ganz Europa und fand im Mittelalter auch Eingang in die Gärten, wenngleich zum Verzehr noch lange die Früchte der wild wachsenden Sträucher gesammelt wurden, die schon im zeitigen Frühjahr durch ihre gelben Kätzchenblüten auffallen; der Blick auf ihre Schönheit wird aber vielen Heuschnupfenkranken durch eine Pollenallergie verleidet. In den Bereich des Sagenumwobenen und ein wenig Esoterischen bringen uns dagegen die Zweige der Hasel, denn abgeschnittene Astgabeln dienen seit langem bevorzugt als Wünschelrute, um alles Mögliche, nicht nur Wasser, aufzuspüren. Neben den wildwachsenden Haselnüssen spielen auf dem Markt heute nur noch die im 16. Jahrhundert um Würzburg und Bamberg gezüchteten großen Zeller Nüsse sowie die nach ihrer Herkunft aus der Lombardei als Lambertnuss bezeichnete Art mit kleinen roten Nüssen eine Rolle. Am Ende des 18. Jahrhunderts kam zusätzlich noch die amerikanische Hasel nach Europa und durch vielfältige Kreuzung zwischen all diesen Verwandten selektierten die Züchter seit dem 19. Jahrhundert die heutigen Sorten.

Dans son *Histoire naturelle*, Pline appelle la noisette la « noix pontique », ce qui donne un indice sur sa terre d'origine, l'Asie mineure. Mais la noisette s'est vite répandue dans toute l'Europe où elle a fait son entrée dans les jardins dès le Moyen Age. Pour la consommation, on cueillit encore pendant longtemps le fruit des arbustes sauvages, qui tôt au printemps se signalent par leur floraison de chatons jaunes. Mais ceux que leur pollen rend allergique ou qui craignent le rhume des foins s'en écartent avec prudence. Avec la branche de noisetier, nous entrons dans le royaume des légendes et de l'ésotérisme, car une fourche coupée de cet arbre a longtemps servi de baguette de sourcier, pour rechercher de l'eau et toutes sortes d'autres choses. Outre la noisette sauvage, seules la grosse *noix de Zell* cultivée au XVIᵉ siècle dans la région de Wurtzbourg et de Bamberg et la noisette franche, plus petite et rouge, originaire de Lombardie, occupe encore aujourd'hui une place significative sur les marchés. A la fin du XVIIIᵉ siècle, leur cousine américaine se joint à cette petite famille et après de multiples croisements entre elles, les cultivateurs ont sélectionné à partir du XIXᵉ siècle les variétés d'aujourd'hui.

PLATE LXXIII
White Filbert · Scarlet Filbert · Great Cob · Barcelona · Varieties · White Hazel Nut · Brown Hazel Nut
Weiße Lambertnuss · Rote Lambertnuss · Spanische Lambertnuss · Englische Zellernuss · Varietäten ·
Weiße Haselnuss · Braune Haselnuss
Aveline blanche · Aveline rouge · Noisetier d'Espagne · Barcelone · Variétés · Noisette blanche · Noisette brune

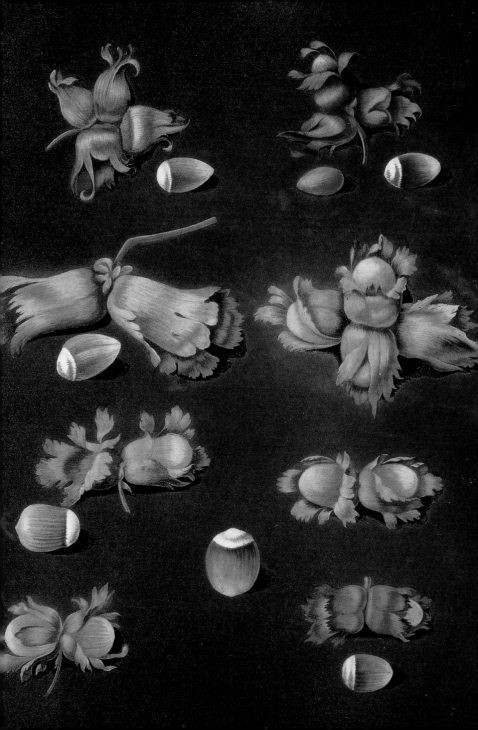

FIGS
Feigen | Figues

Botanists place the fig tree in the mulberry family. It is native to Caria, that part of the southwestern coast of Asia Minor off which the islands of Rhodes and Kos are located. The specific botanical name *Ficus carica* still reveals this origin. At the latest around 700 B.C. the fig tree arrived in Greece, thence or via the Phoenicians to Italy, where the fig harvest is an important economic factor even today. The tree or bush with its large, hand-shaped, lobed leaves and pear-shaped green or dark red fruits can be found throughout the Mediterranean and many climatically amenable regions of Asia and North Africa. Figs are even cultivated along the German wine route. When the tree is injured, it secretes a white, latex-like milk that is very adhesive. It was noticed very early on that it causes milk to curdle, which is why people were advised not to drink milk after eating figs. A fig cheese is still made in Spain, as well as dessert wines and a coffee substitute. Most figs are eaten fresh or dried, however, and are intensely sweet treats, due to their high sugar content, but for this reason they also stimulate the digestion and have a laxative effect.

Botanisch gehört der Feigenbaum zu den Maulbeergewächsen. Seine Heimat hat er in der antiken Landschaft Karien, jenem Teil der Südwestküste Kleinasiens, dem die Inseln Rhodos und Kos vorgelagert sind. Im botanischen Namen *Ficus carica* kommt diese Herkunft noch heute zum Ausdruck. Spätestens um 700 v.Chr. kam der Feigenbaum nach Griechenland und von dort oder über phönizische Vermittlung nach Italien, wo die Ernte seiner Früchte noch heute einen wichtigen Wirtschaftsfaktor ausmacht. Im gesamten Mittelmeergebiet und vielen klimatisch geeigneten Regionen Asiens und Nordafrikas findet sich der Baum oder Strauch mit seinen großen, handförmig gelappten Blättern und den birnförmigen grünen oder dunkelroten Früchten. Sogar an der Deutschen Weinstraße wird die Feige zur Fruchtreife gebracht. Bei Verletzungen des Baumes tritt ein weißer, latexartiger Milchsaft aus, der stark klebt. Schon früh hat man bemerkt, dass er Milch zur Gerinnung bringt, weshalb abgeraten wurde, nach dem Genuss von Feigen Milch zu trinken. In Spanien wird noch heute ein Feigenkäse hergestellt, aber auch Dessertweine und Feigenkaffee werden aus den Früchten gewonnen. Der Großteil wird jedoch frisch oder getrocknet gegessen und erfreut den Genießer wegen des hohen Zuckergehalts durch eine auffallende Süße, wirkt aus dem gleichen Grund aber auch verdauungsanregend und abführend.

Le figuier appartient à la famille des moracées. Il est né dans les paysages de l'antique Carie, région côtière du sud-ouest de l'Asie mineure, face aux îles de Rhodes et de Cos. Cette origine est restée inscrite dans son nom botanique, *ficus carica*. Vers 700 av. J.-C. au plus tard, le figuier s'implante en Grèce et de là, ou par l'intermédiaire des Phéniciens, en Italie, où son fruit alimente encore aujourd'hui un marché important. Arbre ou arbrisseau aux larges feuilles lobées en forme de main, il est, avec ses fruits piriformes verts ou rouge profond, une marque caractéristique du paysage méditerranéen et de nombreuses régions d'Asie et d'Afrique du Nord au climat ressemblant. Même en Allemagne, on voit mûrir la figue sur la route des vins. Une entaille dans l'arbre fait apparaître un jus blanc laiteux, extrêmement collant, semblable à du latex. L'homme ayant très tôt constaté que ce jus faisait cailler le lait, il a été déconseillé de boire du lait après avoir mangé des figues. Encore aujourd'hui, les Espagnols fabriquent un fromage, des vins de dessert et un café à base de ce fruit. Mais pour l'essentiel, les figues sont consommées fraîches ou séchées et réjouissent le gourmet par leur haute teneur en sucre, qui stimule la digestion et exerce un effet laxatif.

PLATE LXXIV

White Hanover · White Marseilles · Brown Naples · Purple Fig · Green Ischia · Brunswick

Weiße Hannover · Große Weiße Feige · Morellenfeige (Braune Neapolitanerin) · Birnenfeige ·
Grüne Ischia-Feige · Madonnenfeige (Braunschweiger Feige)

Hanovre blanc · Figue blanche · Fleur rouge · Figue poire · Ischia verte à longue queue · Brunswick

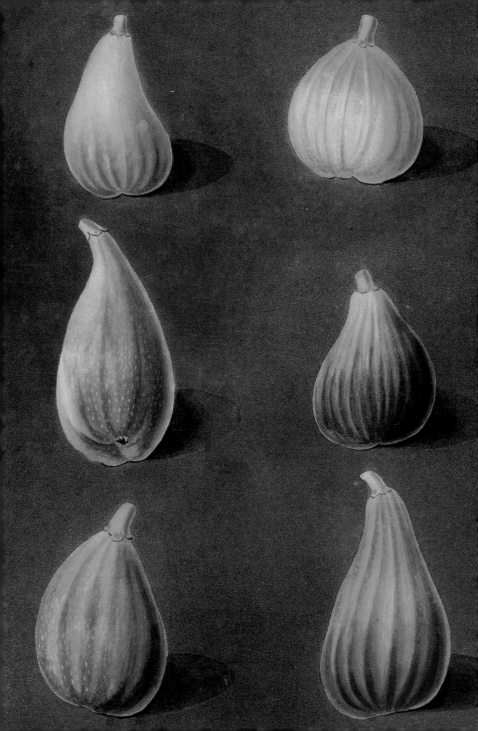

PLATE LXXV

Green Ischia · Red Turkey Fig · Earl of Besborary · — · Brown Malta · Black Ischia

Grüne Ischia-Feige · Rote Türkische Feige · Graf von Besborary · — · Gemeine runde Feige (Braune Malteser Feige) · Schwarze
Ischia-Feige

Ischia verte à longue queue · Figue rouge de Turquie · — · — · Malta brune · Ischia noire

106

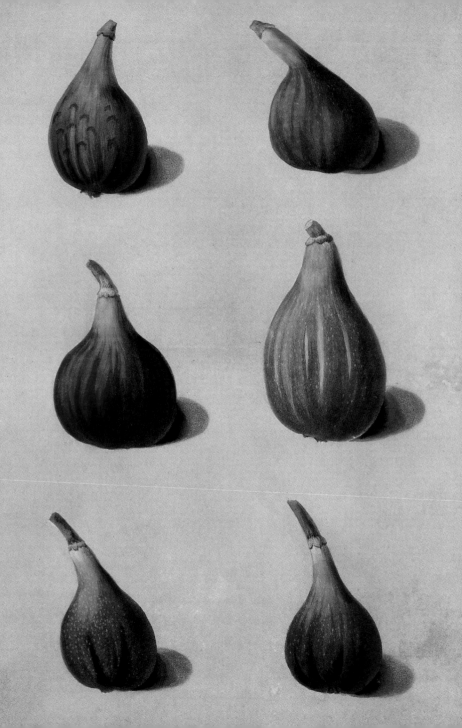

PEARS
Birnen | Poires

Homer mentioned pears in his *Odyssey* and Pliny, of course, described them in his monumental *Historia naturalis*, where we are not only introduced by name to many different varieties, but also learn that it was considered the fruit of the goddess of love, Venus. With such bright white blossoms and crimson stamens, who would be surprised? Pears were cultivated in the Mediterranean for around 3000 years. But they originate from western Asia and became known to the Greeks and Romans from Asia Minor, who soon preferred them to the native wild varieties. Those small and hard fruits are graphically described in German as "woody" (*Holzbirne*) and are only edible after cooking. Most of the modern hybrids are noted for their "buttery"-textured, juicy flesh that gives off a characteristic, fine aroma at room temperature. These varieties were developed in the mid-18th century and French, Belgian and German crosses have become particularly popular. Around 1770 the Williams' Bon Chrétien pear was bred in England and has since become the most important variety today in the canning industry (known in America as the Bartlett).

Homer erwähnt die Birne in seiner *Odyssee* und natürlich findet sie sich auch in der monumentalen *Historia naturalis* des Plinius beschrieben, wo wir nicht nur eine große Zahl unterschiedlicher Sorten namentlich kennen lernen, sondern auch erfahren, dass sie als Frucht der Liebesgöttin Venus galt. Wen wundert's bei den leuchtend weißen Blütenblätter und den roten Staubgefäßen? Seit etwa dreitausend Jahren wird die Birne im Mittelmeerraum kultiviert, stammt ursprünglich jedoch aus Westasien und wurde über Kleinasien den Griechen und Römern bekannt, die sie schnell den einheimischen Wildsorten vorzogen. Ihre kleinen und harten Früchte werden „Holzbirne" genannt und sind allenfalls gekocht genießbar. Dagegen zeichnen sich die meisten der neuzeitlichen Züchtungen durch weich schmelzendes Fruchtfleisch aus, das sehr viel Saft führt und bei Zimmertemperatur das charakteristische feine Aroma entfaltet. Sie bildeten sich seit der Mitte des 18. Jahrhunderts heraus, wobei sich insbesondere französische und belgische, aber auch deutsche Züchtungen großer Beliebtheit erfreuten. Aus England kam um 1770 die Williams-Christ-Birne, die heute in der Konservenindustrie die größte Bedeutung besitzt.

Homer évoque la poire dans son *Odyssée* et on la trouve bien sûr mentionnée dans la vaste *Historia naturalis* de Pline qui en décrit un grand nombre de variétés et nous apprend qu'elle était considérée comme le fruit de Vénus, déesse de l'amour. On ne s'en étonnera pas à la vue de ses fleurs blanches et lumineuses et de ses étamines rouges. La poire est cultivée depuis environ 3000 ans dans le bassin méditerranéen mais provient d'Asie occidentale. Les Grecs et les Romains la découvrirent en Asie mineure et la préférèrent bientôt aux variétés sauvages de leurs contrées, dont les fruits petits et durs sont appelés « poires des bois » en allemand et qui peuvent se manger cuits. En revanche, la plupart des variétés plus récentes se distinguent par leur chair fondante, très juteuse, et dégagent un arôme caractéristique à température ambiante. La plupart ont été développées à partir du milieu du XVIIIᵉ siècle, les variétés françaises et belges mais aussi allemandes ayant eu le plus grand succès. L'Angleterre a donné naissance vers 1770 à la poire Williams, la plus employée aujourd'hui dans l'industrie de la conserve.

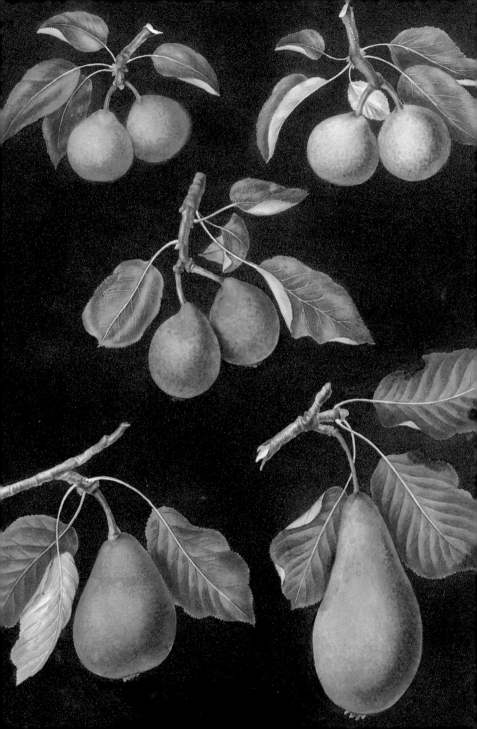

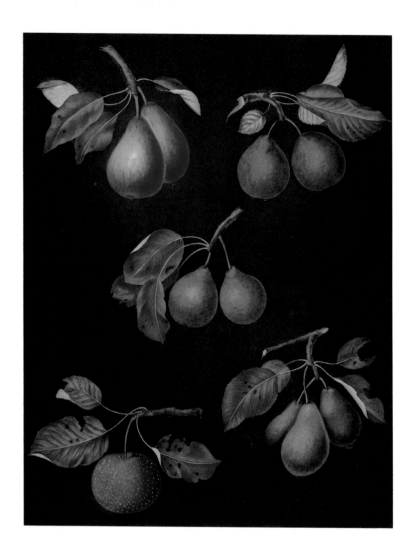

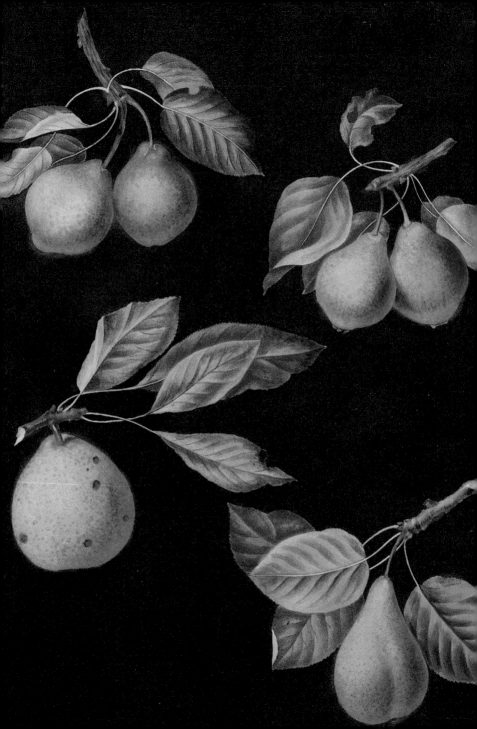

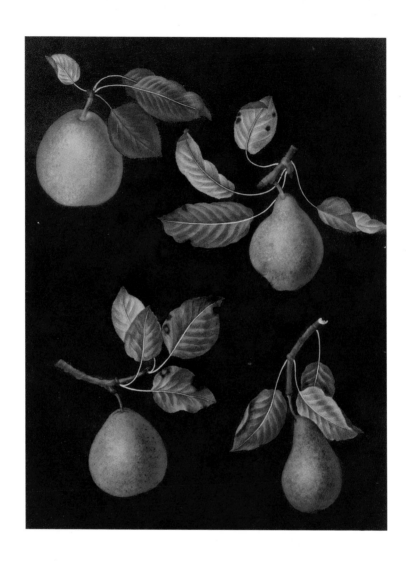

PLATE LXXIX
Bergamot de Chantilly · Bonchee (Bon Chretien) · White Sweet Sugar Pear · Bishop Thumb
Bergamotte aus Chantilly · — · — · Bishop Thump
Bergamote de Chantilly · — · — · —

PLATE LXXX
Chaumontelle Pear · Windsor Pear · Summer Bon Chretien
Wildling von Chaumontel · Römische Schmalzbirne · Sommer-Apothekerbirne
Besy de Chaumontel · Poire Madame · Bon Chrétien d'été

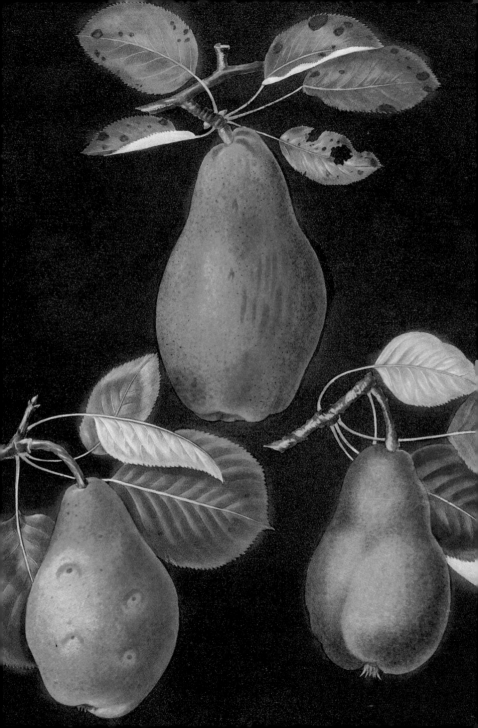

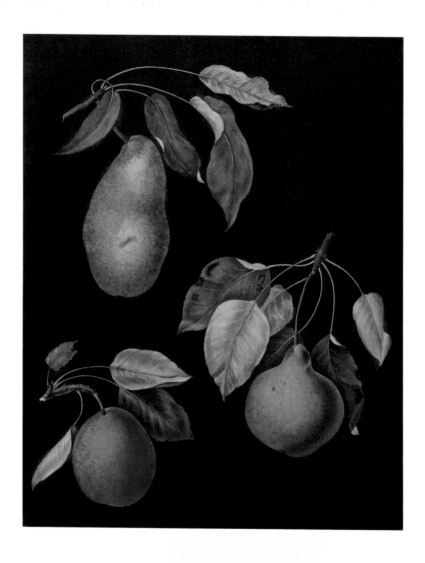

PLATE LXXXI
Double Blossom Pear · Swan's Egg Pear · Winter Swan's Egg Pear
Doppelt tragende Birne (Zweiträchtige) · Schwanenei-Birne · —
Double fleur · — · —

PLATE LXXXII
Brown Beurré · Golden Beurré (Pear) · Colmar Pear
Graue Herbstbutterbirne (Braune Butterbirne) · Goldbirne aus Bilbao · Colmar (Mannabirne)
Bayenne gris (Beurré gris) · Golden Beurré (Bilbao) · Poire de Colmar

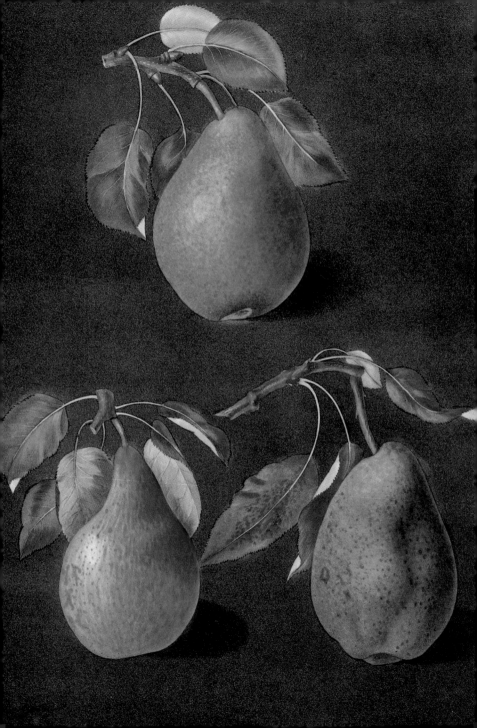

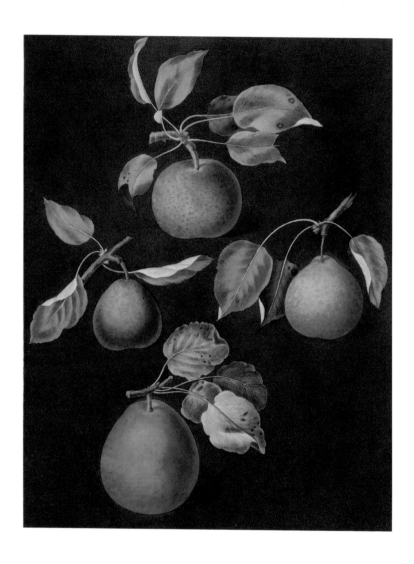

PLATE LXXXIII
Crassane Pear · Summer Bergamot · Orange Bergamot · — ·
Crassane · Große Sommer-Bergamotte · Orange Sommer-Bergamotte · — ·
Bergamote Crassane · Bergamote d'été · — · — ·

PLATE LXXXIV
Virgouleuse · Striped Vert Longue · — · Pear d'Auch
Virguleuse · Schweizerhose · — · Winter-Apothekerbirne von Auch
Poire de Virgouleuse · Bergamote suisse longue · — · Bon Chrétien d'hiver Auch

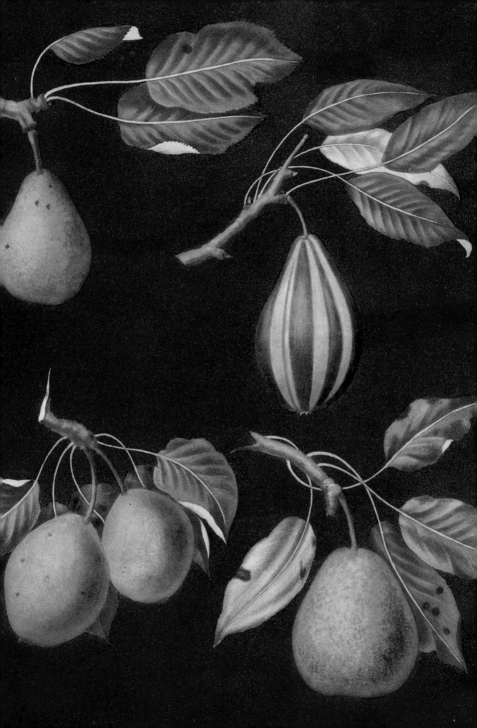

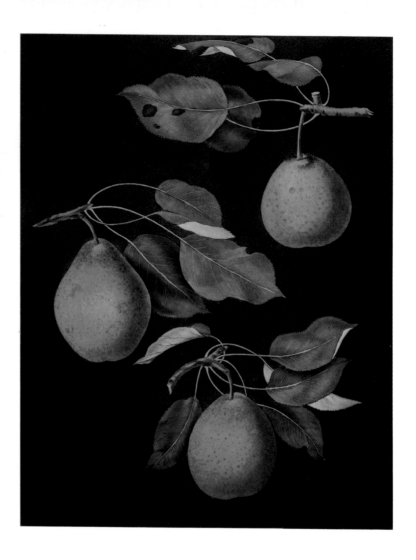

PLATE LXXXV
Easter Bergamot Pear · Tarlington Pear · —
Osterbergamotte · Tartling (?) · —
Bergamote de Pâques · — · —

PLATE LXXXVI
Cadillac · Paddington Pear · St. Martial Pear
Großer Katzenkopf · Winterdechantsbirne · Angelikabirne (St. Martial Birne)
Catillac · Doyenne d'hiver · Angélique (Saint Martial)

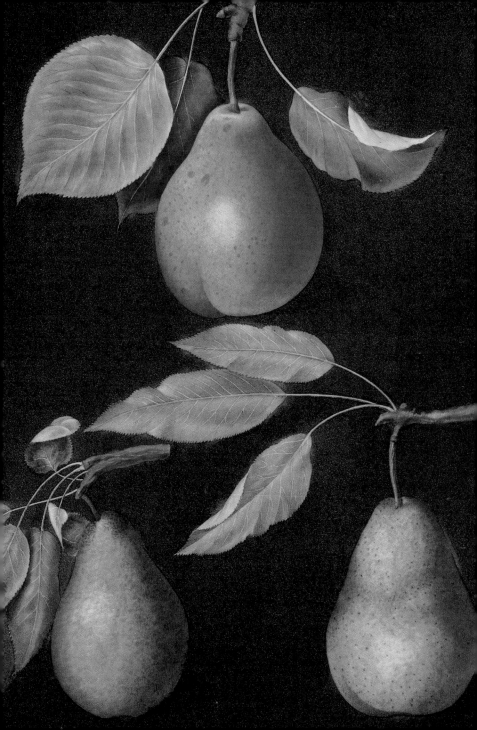

APPLES
Äpfel | Pommes

The grand entrance of the apple was, without a doubt, in Eden, although it is not even explicitly named in the Bible. Only "fruits" are mentioned there, and in particular that forbidden fruit from the tree of the knowledge "of good and evil", *bonum et malum*, as it reads in the Vulgate. But since the Latin *malum* can mean either "evil" or "apple", the conceptual link between the two terms was more than suggestive.

Apples have accompanied mankind since time immemorial. Around 5000 years ago cultivation gradually began in the Near East. The first crossbreedings opened the way to ever tastier and prettier fruits. The true cultivation began only in the 16th century and was so successful from the 18th century onward that we now know of more than 20,000 different apple varieties.

Botanically, apple trees belong to the rose family. After pollination, the base of the five-petalled blossoms grows around the carpel to develop into the soft succulent flesh surrounding the seed-carrying core. Besides fruit acids, sugars, and carbohydrates, apples contain numerous minerals and vitamins, which make them as nutritious as they are tasty.

Seinen großen Auftritt hatte der Apfel zweifellos im Paradies, auch wenn er in der Bibel gar nicht erwähnt wird. Lediglich von „Früchten" ist dort die Rede und ganz besonders von jener verbotenen Frucht, die erkennen lasse, was „gut und böse ist" – „bonum et malum", wie es in der lateinischen Vulgata heißt. Da aber im Lateinischen „malum" sowohl „das Böse" als auch „Apfel" bedeuten kann, lag die gedankliche Verbindung beider Begriffe mehr als nahe.

Äpfel begleiten den Weg der Menschen schon seit unvordenklichen Zeiten. Vor etwa 5000 Jahren begann im vorderasiatischen Raum nach und nach die Kultivierung, und so kam man über erste Kreuzungen zu immer ansehnlicheren Früchten. Die eigentliche Kultur beginnt erst im 16. Jahrhundert und erreicht seit dem 18. Jahrhundert derartige Erfolge, dass wir heute mehr als 20 000 verschiedene Apfelsorten kennen.

Botanisch gehört der Apfelbaum zu den Rosengewächsen. Der Boden der fünfzähligen Blüten umwächst nach der Bestäubung die Fruchtblätter und bildet dabei die saftige, weich werdende Fruchtfleisch, das das Kernhaus mit den Samen umgibt. Neben Fruchtsäuren, Zuckern und Kohlehydraten finden sich auch zahlreiche Mineralstoffe und Vitamine im Apfel, die ihn zu einem wertvollen Nahrungsmittel machen.

C'est évidemment par la porte du paradis que la pomme réalise sa grande entrée en scène. Pourtant, elle n'est nullement mentionnée dans la Bible. Il y est seulement question de fruits, et notamment du fruit interdit, qui permet de distinguer entre le Bien et le Mal, lit-on dans la Vulgate latine. Or comme en latin « malum » veut dire « le mal » mais aussi la « pomme », l'association entre ces deux notions s'est faite tout naturellement.

Il est vrai que la pomme est l'amie de l'homme depuis la nuit des temps. Cueillie au départ à l'état sauvage, sous forme de très petits fruits, elle commence à être cultivée il y a environ 5000 ans en Asie mineure pour devenir progressivement, par croisements successifs, un fruit de plus en plus délicieux et de belle apparence. La culture proprement dite de la pomme commence véritablement au XVIᵉ siècle et emporte de tels succès depuis le XVIIIᵉ siècle que nous connaissons aujourd'hui plus de 20 000 variétés de pommes différentes.

D'un point de vue botanique, le pommier fait partie de la famille des rosacées. Après la pollinisation, le fond des fleurs à cinq pétales pousse autour des étamines en donnant naissance à une chair tendre et juteuse qui entoure le trognon et ses pépins. La pomme contient des acides, des sucres, des glucides ainsi que de nombreux sels minéraux et vitamines qui font d'elle un aliment précieux.

PLATE LXXXVII
Pomme d'Api · Carpendu de Blanch · Carpendu de Rouge · Nonsuch Apple Royal · Nonsuch Summer · Margill
Kleiner Api · Weißer Kurzstiel · Königlicher Kurzstiel (Roter Kurzstiel) · Königlicher Sondergleichen ·
Früher Nonpareil (Wicks Liebling) · Muskatrenette
Pomme d'Api · Court-pendu blanc · Court-pendu rouge · Non-pareille royale · Non-pareille d'été · Reinette muscate

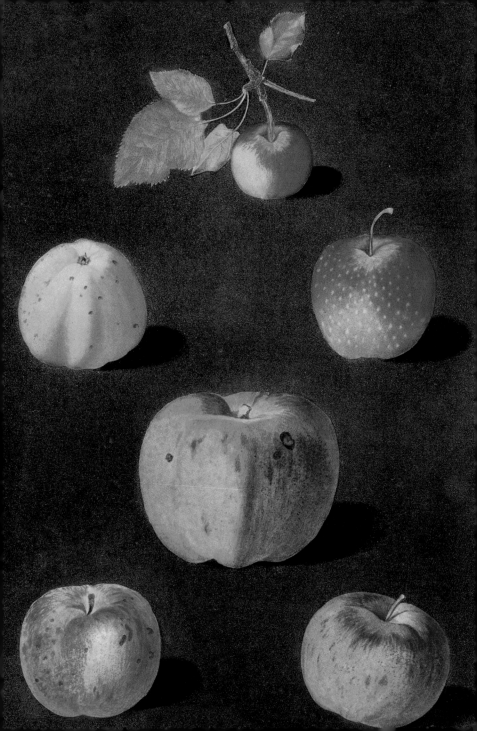

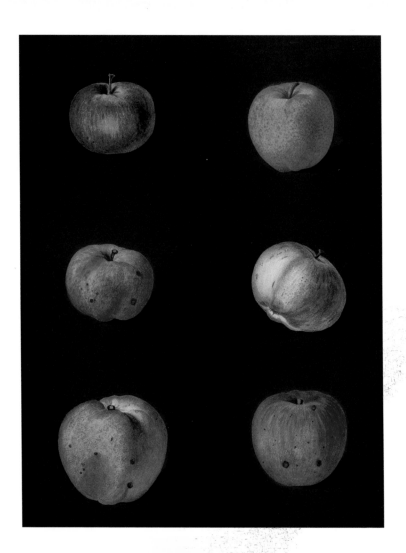

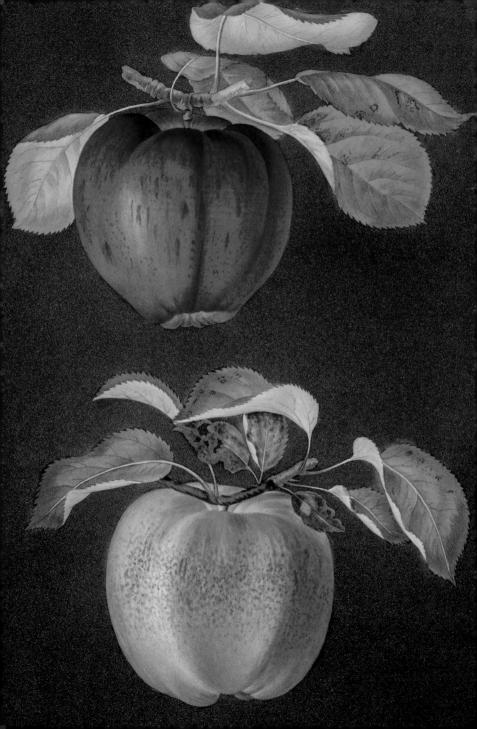

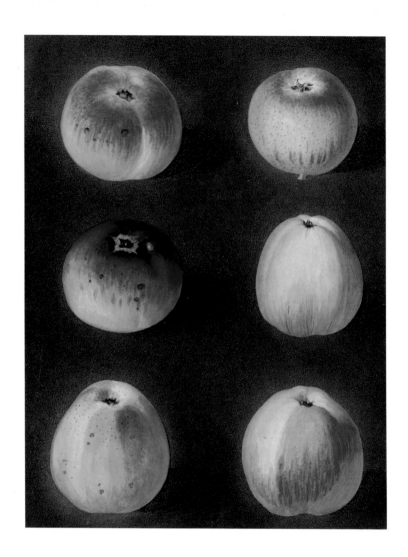

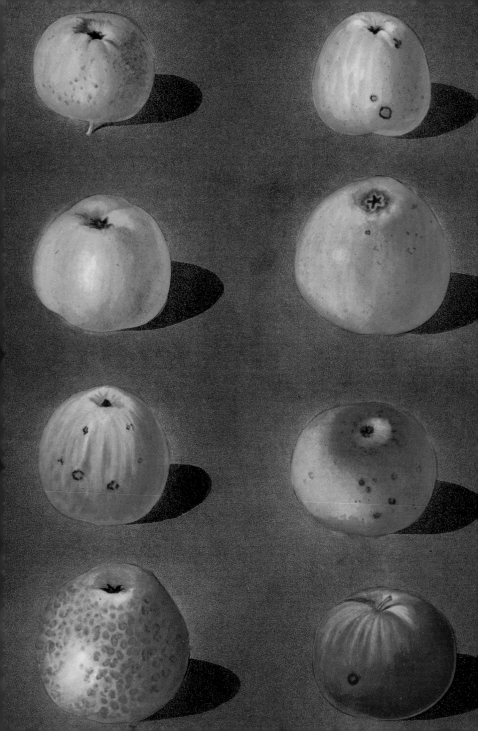

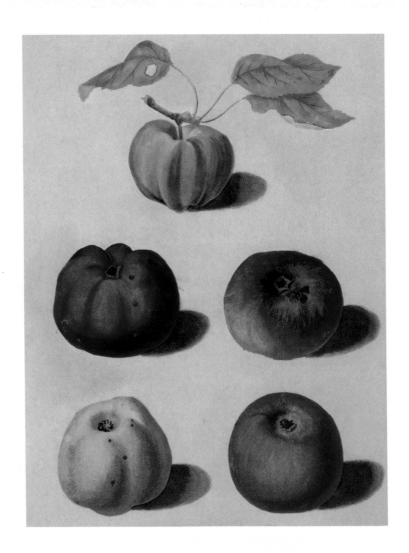

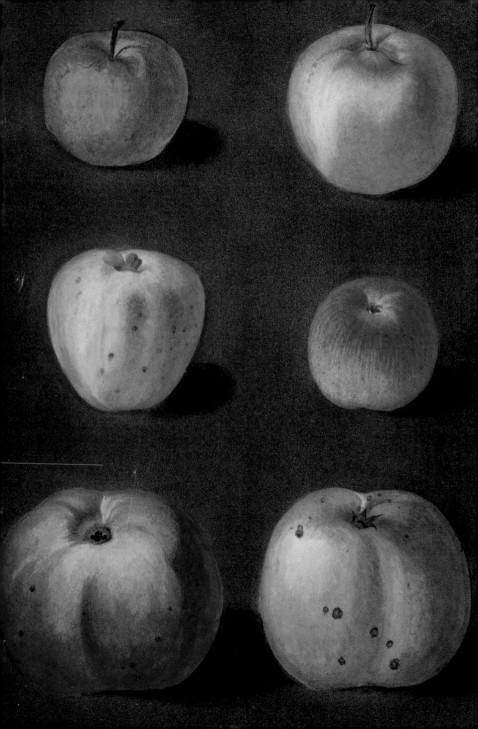

ACKNOWLEDGEMENTS
The copy used for printing belongs to the Staatliche Bücher- und Kupferstichsammlung Greiz/
Thuringia. We thank Gotthard Brandler and the libraries' employees for their friendly assistance.

DANKSAGUNG
Der Druck erfolgte nach dem Exemplar in der Staatlichen Bücher- und Kupferstichsammlung
Greiz/Thüringen. Wir danken Gotthard Brandler und den Mitarbeitern der Bibliothek für die
freundliche Unterstützung.

REMERCIEMENTS
L'impression a été effectuée d'après l'exemplaire de la Staatliche Bücher- und Kupferstichsammlung
Greiz/Thüringen. Nous remercions Gotthard Brandler et le personnel de la bibliothèque pour son
aimable soutien.

To stay informed about upcoming TASCHEN titles, please
request our magazine at www.taschen.com or write to
TASCHEN, Hohenzollernring 53, D–50672 Cologne, Germany,
Fax: +49-221-254919. We will be happy to send you a free
copy of our magazine which is filled with information
about all of our books.

Descriptions of the plates: Werner Dressendörfer, Bamberg

Project management: Petra Lamers-Schütze, Cologne
Photographs: Christoph Schmidt, Berlin
Botanical editing: Walter Hartmann, Hohenheim
English translation: Ann Hentschel, Göttingen
French translation: Anne Charrière, Croissy-sur-Seine
Design: Claudia Frey, Cologne
Production: Martina Ciborowius, Cologne

Printed in Italy
ISBN 3–8228–4740–2